Filippo Pedrocco

CANALETTO
and the Venetian Vedutisti

SCALA/RIVERSIDE

INDEX

The Origins	3
Luca Carlevarijs	9
Canaletto	20
Bernardo Bellotto	54
Michele Marieschi and Francesco Albotto	56
Francesco Guardi	65
Index of Illustrations	79
Bibliography	80

Photographic acknowledgements: SCALA ARCHIVE except for nos. 3, 4, 8, 10, 11, 19, 20, 65, 66, 78, 82, 83 (by courtesy of the author); no. 7 (Osvaldo Böhm, Venice); nos. 14, 15 (Potsdam, Stiftung Preussische Schlösser und Gärten); no. 16 (Artothek, Peissenberg); nos. 18, 79, 97 (by courtesy of the Ashmolean Museum, Oxford); nos. 24, 25, 29 (Fundación Colección Thyssen Bornemisza, Madrid); nos. 30, 32, 59 (by courtesy of the Royal Collection, Her Majesty Queen Elizabeth II); no. 31 (by courtesy of the Fogg Art Museum, Harvard University, Cambridge); nos. 36, 37, 69, 70 (Izobrazitelnoye Iskusstvo); nos. 38, 39, 53, 54 (by courtesy of the National Gallery, London); nos. 42, 43, 44, 45 (by kind permission of the Marquess of Tavistock and the Trustees of Bedford Estate); no. 46 (by courtesy of the Museum of Fine Arts, Boston); no. 55 (by courtesy of the Toledo Museum of Arts); no. 60 (Roudnice Lobkowicz Collection, Prague); no. 61 (by courtesy of Dulwich College Picture Gallery, London); no. 62 (by courtesy of the Dean and Chapter of Westminster); no. 77 (Archivio Pedicini, Naples); nos. 96, 98 (Calouste Gulbenkian Museum, Lisbon)
Translation: Christopher Evans
Layout: Ilaria Casalino
Printed in Italy by Amilcare Pizzi S.p.A.-arti grafiche Cinisello Balsamo (Milan), 1995

Published by Riverside Book Company, Inc.
250 West 57th Street
New York, N.Y. 10107

ISBN 1-878351-49-4

1. Gentile Bellini
The Procession in Piazza S. Marco
Venice, Gallerie dell'Accademia

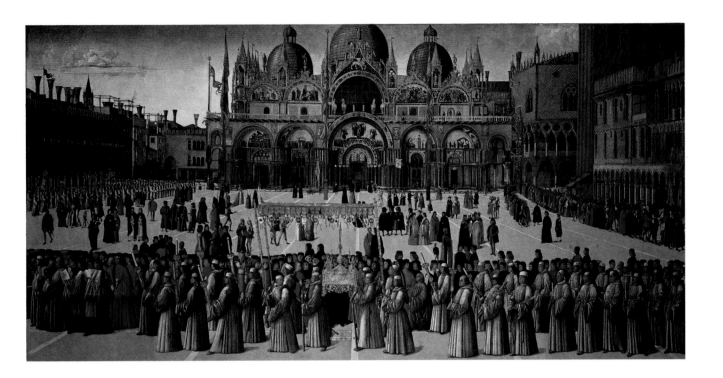

The Origins

It is a deep-rooted tradition among writers of history that Venice went through a deep crisis in the eighteenth century, a crisis that was both the harbinger and cause of the conclusion, in the May of 1797, of the thousand-year existence of the Serenissima, as the Republic of Venice was known. On closer examination, however, this crisis turns out to have been restricted largely to the Republic's institutions, evident in the ruling oligarchy's inability to renew its own structure and adapt it to changing political, social, and economic requirements. In other areas, though, the lagoon city was experiencing one of its periods of greatest splendor, underlined by exceptional fervor in the field of art and culture. The face of the city itself was undergoing profound changes: numerous new churches were built, from that of San Stae to that of Santa Maria della Consolazione or della Fava, from the Gesuiti to the Gesuati, from the Pietà to San Simeone Piccolo and the neoclassical Maddalena del Temanza. New public buildings were going up, including the Teatro della Fenice. Many private residences were built from scratch (Palazzo Grassi, Ca' Corner della Regina, Palazzo Duodo, and Ca' Venier dei Leoni, just to mention the most important), while others were enlarged (Ca' Labia), restored, and modified to suit the taste of the time (Palazzo Balbi Valmarana Smith, Ca' Dolfin Manin), or completed (Ca' Rezzonico). Several great Schools completely renovated their old seats (La Carità, I Carmini, San Giovanni Evangelista).

Painters played a preeminent role in this frenzy of construction, as they were called on to decorate the new buildings with canvases and frescoes: from the matchless Tiepolo to Sebastiano Ricci, and from Crosato to Piazzetta and Diziani. Yet Venetian artists did not just specialize in the large-scale decorations with a historical, religious, or mythological theme required by this type of patronage, but in all the other genres as well. In portraiture, with the delightful pastels of Rosalba Carriera, to be counted among the highest achievements of rococo, and with the courtly images of Alessandro Longhi; in landscape, a field dominated by the classical works of Marco Ricci and the Arcadian style of Giuseppe Zais and Francesco Zuccarelli; in the genre scene, with the small but penetrating canvases of Pietro Longhi; and finally in the landscape and views of the city itself.

It is curious to note that this last genre of painting was less highly regarded in local artistic circles than the others, with the result that the most celebrated artist working in that field, Antonio Canal known as Canaletto, was not admitted to the Academy of Painting and Sculpture until several years after its institution, in 1763. And yet this genre is an extremely important one, not only because of the quality of the works that it produced, but also and above all because it has spread the unique image of the lagoon city through the world, making a decisive contribution to the birth of the *myth* of Venice.

The custom of filling their canvases with images of Venice was certainly not a monopoly of eighteenth-

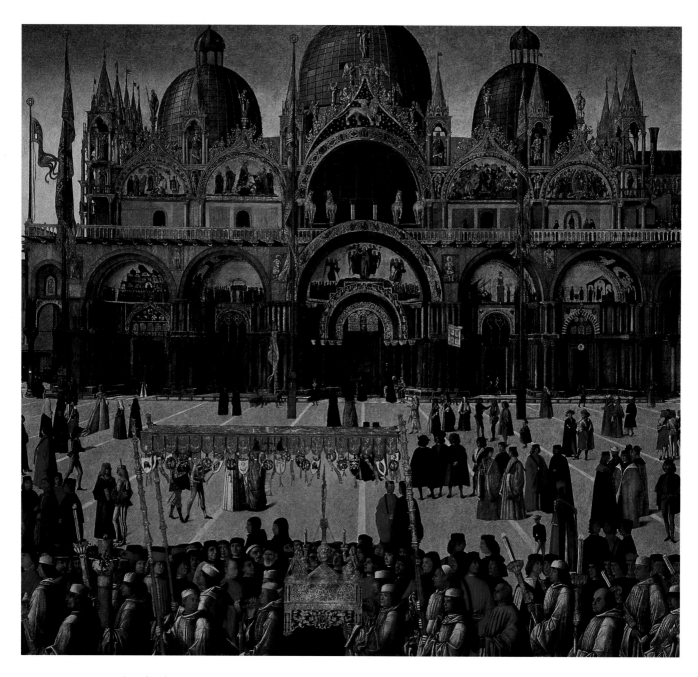

century painters, but had deep roots in the local figurative culture. In fact it is possible that the first decoration of the Doge's Palace, dating from the fourteenth century and subsequently destroyed, included a number of representations that contained precise references to places in Venice, for instance in the scenes telling the story of the reconciliation between Pope Alexander III and Emperor Frederick Barbarossa, which took place in Venice through the mediation of Doge Sebastiano Ziani. While this is no more than a hypothesis, it is certain that Venice is triumphantly present in the series of *teleri*, or large canvases, painted in the last decade of the fifteenth century by Gentile Bellini and his assistants for the hall of the Albergo della Scuola Grande di San Giovanni Evangelista, now in the Gallerie dell'Accademia. In his depiction of the miraculous events brought about by the reliquary of the Cross kept in the School, Gentile chose the most realistic approach, setting them

in the places where the miracles were actually supposed to have occurred. Thus the merchant Jacopo de Solis calls for help for his sick son during the procession through St Mark's Square, and the miraculous healing of a madman by the Patriarch of Grado, Francesco Querini, takes place in a loggia of the palace that the latter owned on the bank of the Vin, near Rialto.

The images of the city furnished by Bellini and Carpaccio — the authors of these paintings — are clear, distinguished by a realism of almost Northern European stamp, to such an extent that it is possible to recognize features of Venetian topography that have since been modified: the old layout of the area of St Mark's, with the hospice of the Orseolo on the right, where the Procuratie Nuove now stand; or, in Gentile's painting, the iconography of the original mosaics on the front of St Mark's, only one of which has survived; the wooden drawbridge that linked the area of the Rialto market

4

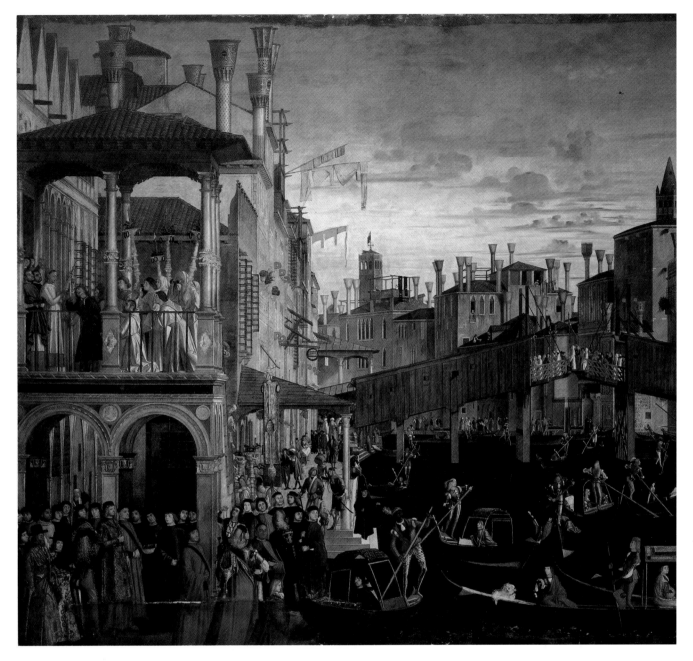

2. Gentile Bellini
The Procession in Piazza S. Marco, detail
Venice, Gallerie dell'Accademia

3. Vittore Carpaccio
The Miracle of the Relic of the Holy Cross
Venice, Gallerie dell'Accademia

with San Bartolomeo prior to the construction of the stone bridge we know today; or the extremely rare image of the Fondaco dei Persiani, with the whole of its outer walls faced with inlaid marble — looking almost like a refined Oriental carpet — that can be glimpsed on the right, between the piers of the bridge, in Carpaccio's *teler*.

It has often been said that these works cannot be considered *vedute* in the modern sense of the term, in that the city merely provides the backdrop to an event that is taking place, and is not in itself the protagonist of the paintings. Yet it seems obvious that, even though the paintings in question have a narrative intent, it is really late fifteenth-century Venice that plays the leading role, in the splendor of its architecture and the opulence of its everyday reality, and that this reality is the true protagonist of the paintings. In short, if we were to exclude the large canvases painted by Gentile and his pupils for the Scuola di San Giovanni Evangelista from the genre of the *veduta*, then the same would have to be done with many of the eighteenth-century works that are unanimously regarded as examples of *vedutismo*: from the numerous entries of ambassadors painted by Carlevarijs and Canaletto to the regattas, the departures and arrivals of the Bucentaur, and the dogal festivals, to cite only the most famous.

Vice versa, it can be said that Bellini's *teleri*, with their

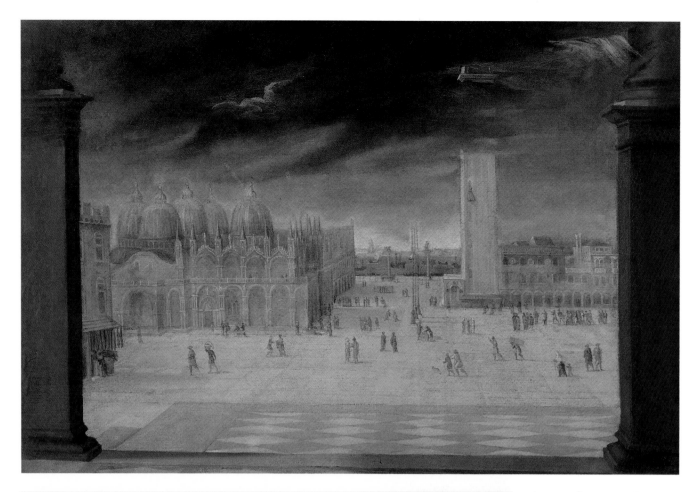

4. Bonifacio de' Pitati
*The Eternal and Piazza
S. Marco, detail
Venice, Gallerie
dell'Accademia*

5. Titian
*Ancona Madonna,
detail
Ancona, Museo Civico*

6. Sebastiano del
Piombo
*Death of Adonis, detail
Florence, Galleria degli
Uffizi*

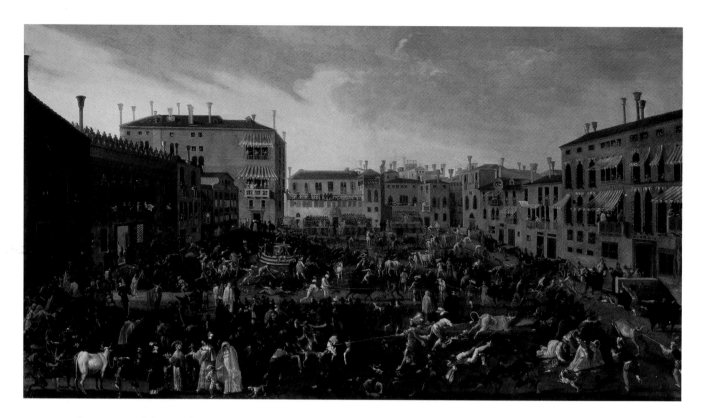

accurate depiction of the city's appearance, were actually the root of eighteenth-century *vedutismo*, for they contain all the elements that were to be found in the works of the artists active two centuries later.

The same predilection for representation of the city crops up, undoubtedly with the intention of eulogizing and celebrating the glories of Venice, in numerous other pictures painted during the Renaissance. In the canvas now in Oxford's Ashmolean Museum, for instance, Giorgione placed his *Madonna reading* next to a window overlooking the basin of St Mark, where it is possible to identify the Doge's Palace and the tower of the campanile, still lacking the spire that was not constructed until 1513. Carpaccio set the same scene alongside the Lion of St Mark, the symbol of the city, that he painted for the Doge's Palace. Even Titian, in the *Ancona Madonna*, has left us an unforgettable back-lit vision of the area of St Mark's seen from the basin. Sebastiano del Piombo painted the death of Adonis — in the canvas now in the Uffizi — on the edges of a wood that he places on the island of San Giorgio, realistically setting in front of it, on the other side of the basin of St Mark, the wharf with the Doge's Palace on the right and the campanile and buildings of the Mint on the left. Finally, in a canvas intended to decorate the offices of a magistrature in the Palazzo dei Camerlenghi, Bonifacio de' Pitati offers us a highly animated picture of St Mark's Square. Painted from a bird's eye view, as had been the fashion ever since the publication of Jacopo de Barbari's excellent woodcut, it looks toward the basin, while the Eternal hovers overhead, accompanied by the dove of the Holy Spirit. Many other views of Venice can also be found in the paintings in the Doge's

7. Joseph Heintz the Younger
The Bull Hunt in
Campo S. Polo
Venice, Museo Correr

Palace, such as the canvases of the Maggior Consiglio or Titian's fresco of *Saint Christopher*.

The example set by these *veduta*-like inserts was not immediately followed up. The fact is that, while the view gradually took on a great deal of importance in the Low Countries and Northern Europe in general, especially in the seventeenth century, Venetian painters of the same period had other interests, which did not include the accurate representation of places.

It was a painter from the north, Joseph Heintz the Younger (ca. 1600 - ca. 1678), a native of Augsburg and trained at the Bohemian court, who revived interest in this specific genre around the middle of the seventeenth century. Heintz — who also painted a large number of historical or religious pictures — produced a long series of works devoted to typical Venetian festivals in 1646 (the date written on one of the canvases now in the Museo Correr in Venice): from the *Bull Hunt in Campo San Polo* to the *Procession to il Redentore*, and from the *Entry into San Pietro di Castello* of the new patriarch to the *Outing by Boat to Murano*. In these paintings the typically Northern European predilection for the accurate reproduction of reality is combined with a lively use of color and effects that already foreshadows the work of certain eighteenth-century *veduta* painters, such as Carlevarijs and Richter.

Luca Carlevarijs

Luca Carlevarijs from Friuli (Udine 1663 - Venice 1730) — whom the sources describe as "knowing a great deal about Architecture" and who was also a student of the science of perspective, as is clearly apparent from the preparatory drawings for his engravings — is rightly considered the father of eighteenth-century Venetian *vedutismo*. His approach to the genre took place by degrees: in fact his early work was in the field of landscape painting, with numerous pictures linked stylistically to the models of such Northern European artists as Cavalier Tempesta, alias Pieter Mulier, Hans de Jode, and Johann Anton Eismann, with whom he came into contact during his visit to Rome as a young man, according to the authoritative testimony of Moschini (1806), as well as in Venice, where many Northern European artists (including Tempesta and Eismann) were present at the end of the seventeenth century.

Carlevarijs's move from landscape to the *veduta* is marked by the collection of 104 engravings entitled *Fabriche, e Vedute di Venetia*, printed in 1703, though it was in fact the fruit of long preparation that must have occupied the artist for several years, and by the execution of a series of canvases depicting solemn entries of foreign ambassadors, on their way to present their credentials to the government of the Serenissima. Such entrances provided an occasion for regattas, parades on the water, and festivals, and in this sense Carlevarijs's canvases were perfectly in keeping with the tradition referred to above, which had its roots in the works produced by the Bellini workshop.

On the other hand the link with Gaspar van Wittel, who is often cited in the literature as the forerunner of eighteenth-century Venetian *vedutismo*, seems to be much less close. Van Wittel came to Rome as a very young man around 1647 and devoted himself to the painting of views, depicting the ancient and modern architecture of the papal city with a cold and calculating eye, in net contrast to the local tradition of landscape painting, whose greatest exponent was Salvator Rosa. In this sense, the example he set was to have a particularly strong influence on the birth of the eighteenth-century school of Roman *veduta* painters, which grew up around the painter Gian Paolo Panini from Piacenza.

In the last decade of the seventeenth century, Van Wittel made numerous journeys to Northern Italy, visiting Venice between the end of 1694 and 1695. It seems certain that he painted no views of the city during his stay, which was fairly short (in fact the ones we know of all bear dates later than 1697), but limited himself to making drawings from life. It was only later, in his studio in Rome, that he used these to produce paintings on canvas. In any case the Venetian *vedute* of Van Wittel — of which about twenty are currently known to exist — are distinguished by their accuracy in the depiction of details, their topographical precision, the crystalline quality of their color, and the exactness of their proportions: all characteristics that are clearly visible in the *Piazzetta* in Rome's Galleria Doria Pamphilj or the *View of the Bacino di S. Marco* in the Prado, dating from 1697, but only to a lesser extent in the works

8. Luca Carlevarijs
Seascape
147.5x179 cm
Private Collection

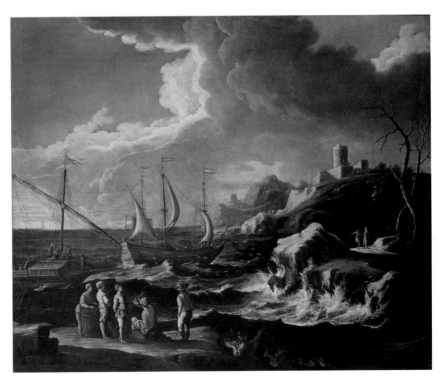

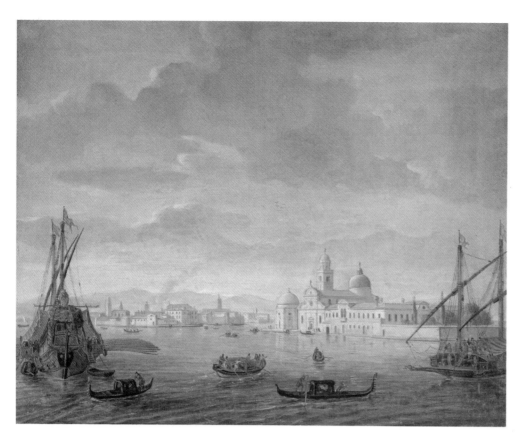

9. Gaspar van Wittel
The Island of San
Michele: looking toward
Murano
36x47 cm
London, private
collection

10, 11. Luca Carlevarijs
The Sea Customs
House with San Giorgio
Maggiore
50x96 cm
Venice, private
collection

of Carlevarijs. What we see in the pictures of the artist from Friuli, in fact, is an evident concession to the picturesqueness typical of the Venetian tradition, and while the rendering of the architecture is fairly precise, it is still shrouded in a rose-colored mist which blurs and softens the details, especially in the background. Often, moreover, the relationship between the works of architecture and the boats and figures that fill the *vedute* is imprecise. Such characteristics are already evident in the oldest paintings representing the entrances of ambassadors to the Doge's Palace, of which the masterpieces appear to be the one recording *Lord Manchester's Embassy to Venice*, on September 22, 1707 (Birmingham, City Museum), and the canvases devoted to the visit by Frederick IV of Denmark (1709), as well as in the earliest *vedute* of Venice, like that of the *Sea Customs House with San Giorgio Maggiore* in a Venetian private collection and the pair of pictures in Potsdam, depicting the *Wharf: looking toward the Doge's Palace* and *Piazza S. Marco with Jugglers*.

Throughout his career Carlevarijs alternated works of landscape — often in the special variety of the *capriccio*, i.e. the fantasy landscape, characterized by the presence of ancient buildings and ruins — with his better known paintings of *vedute* of Venice, though he also tried his hand at the *veduta* of Rome, with the splendid *St Peter's Square* based on a model by van Wittel, in a private collection, or of the Veneto countryside, with the limpid pictures of *Villa Baglioni at Massanzago*, which has recently turned up on the antiquarian market in Venice, or the *Visit to the Villa* in a private

collection in London, for which there is a very fine preparatory drawing in the Museo Correr in Venice.

Particularly excellent results emerged from the prestigious commission he received from Alvise Pisani, perhaps around the beginning of the second decade of the eighteenth century, for several canvases commemorating the crucial moments in the career of that nobleman, who was elected doge in 1735. The best of these is undoubtedly the one recently acquired by the Bayerische Staatsgemäldesammlungen in Munich, depicting the *Arrival of the Venetian Ambassadors Niccolò Erizzo and Alvise Pisani in London*, of great narrative vivacity.

Carlevarijs's style did not change much over the course of time and even his last works — the painter died in 1730, after suffering from progressive paralysis for two years — reveal the same refined skill in staging *vedute* of St Mark's, thronged with numerous and varied figures. In fact it is these figures, drawn from life in black pencil in the numerous sheets of his sketchbook, many of them now in Venice's Museo Correr or the Victoria and Albert Museum in London, that bring to life the paintings, with their gaudy colors and frenetic activity. Works like the *View of the Wharf from the Bacino di S. Marco* in Montecarlo or the *Piazzetta and Library* in the Ashmolean Museum in Oxford, both painted during the last decade of Luca's life, can justly be considered some of the most interesting achievements of eighteenth-century Venetian *vedutismo*.

The figure of Carlevarijs has not so far received the critical appreciation that he deserves. Nevertheless, he

10

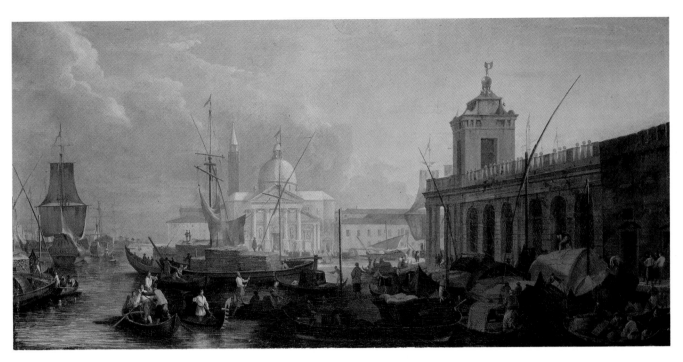

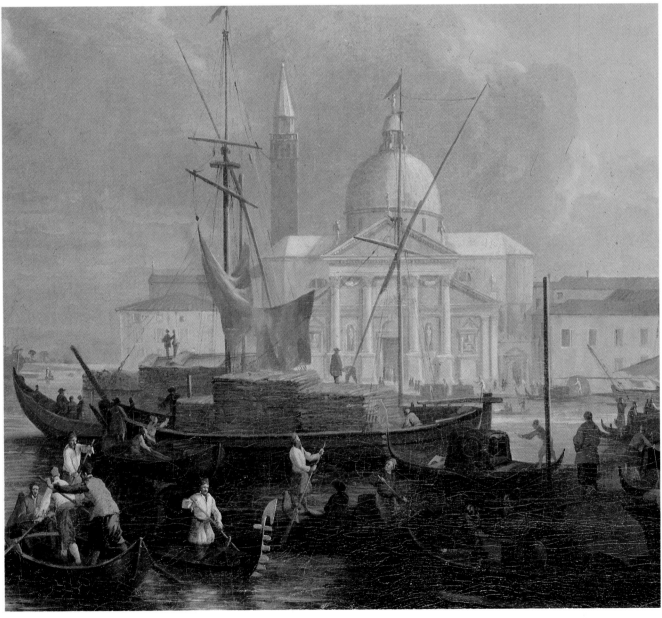

11

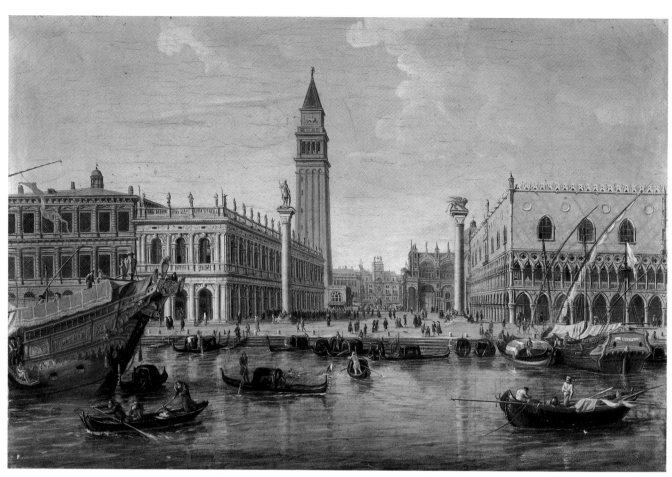

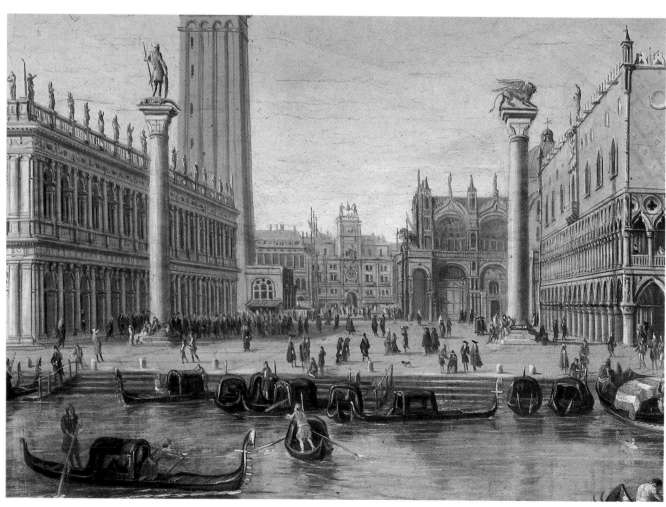

12, 13. Gaspar van Wittel
The Piazzetta: from the Bacino di
S. Marco
27x42 cm
Rome, Galleria Doria Pamphilj

14. Luca Carlevarijs
The Wharf: looking toward the
Doge's Palace
73.4x117.4 cm
Potsdam, Schloss Sans-Souci

15. Luca Carlevarijs
Piazza S. Marco with Jugglers
73.2x117.2 cm
Potsdam, Schloss Sans-Souci

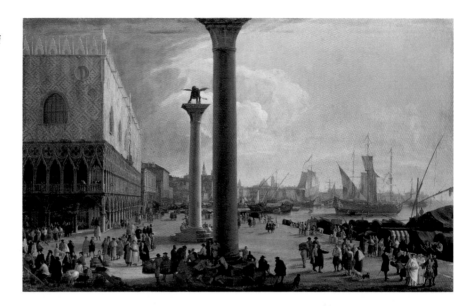

has at least been given the credit, no small thing in itself, for having made a decisive contribution to the renewal of Venetian art, shifting it away from the baroque and turning the attention of local artists toward the landscape and the *veduta*.

Along with Heintz and Carlevarijs, it is worth considering another artist whose work is very little known but of considerable quality, the Alessandro Piazza who painted two series of pictures, the first in the Worchester Art Museum and the second in Venice's Museo Correr, dating from the turn of the century and characterized by rich and dense brushwork and interesting color effects.

Another painter whose style is very similar to Carlevarijs's, with the result that his works are often confused with those of the artist from Friuli, is the Swedish painter Johann (Giovanni) Richter. Born in Stockholm around 1665, he came to Venice in 1710 and stayed there until his death in 1745. Richter was also fond of painting scenes of the area around St Mark's that was so dear to Carlevarijs. Far more original, however, were

his pictures of the lagoon, in which he proposed views that were unprecedented in the Venetian world. In these works (see in particular the *Island of San Giorgio Maggiore* in Stockholm's Nationalmuseum and the *View of the Giudecca Canal* in a private collection in Milan), Richter chose a distant point of view and liked to set boats, often enlivened by the presence of elegantly dressed young women, in the foreground, in a belt of shade that was intended to lend depth to the background. The principal works of architecture were almost never depicted from the front, but at an angle, and were painstakingly represented down to the smallest detail. Frequently — and this is the case with the *veduta* in Milan and various others — the use of the "camera obscura" caused the painter to noticeably reduce the space that actually existed between buildings, resulting in curious "corridor" effects that had nothing to do with reality.

In this Richter — and before him, though in a less obvious manner, the artist who can be considered his master, Carlevarijs — should be seen as the forerun-

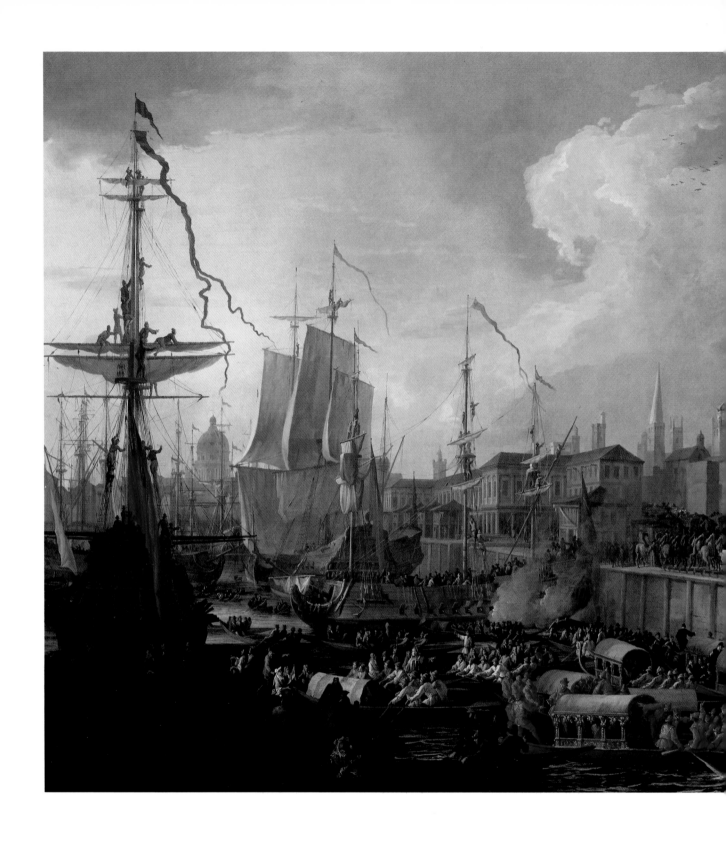

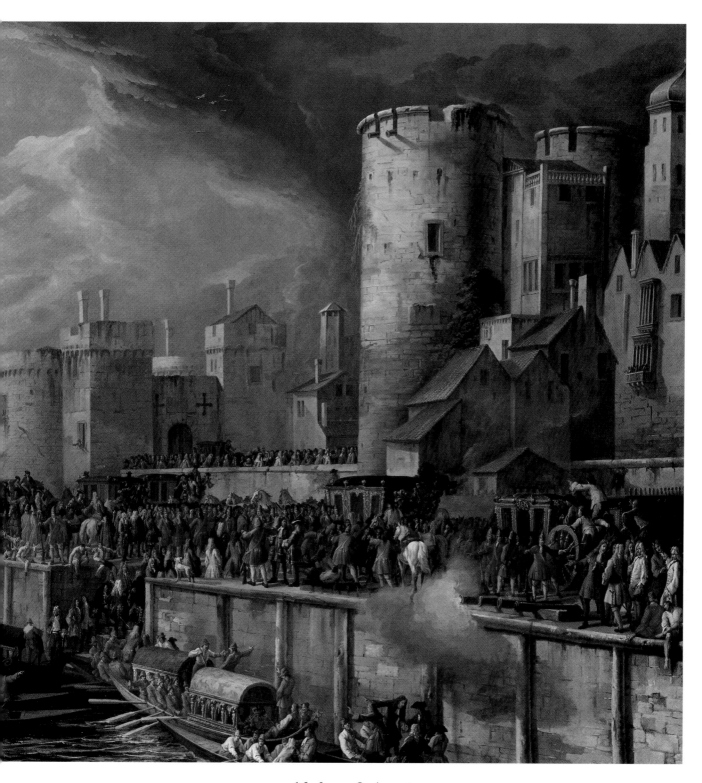

16. Luca Carlevarijs
The Arrival of the Venetian Ambassadors Niccolò Erizzo and Alvise Pisani in London
135.9x252 cm
Munich, Bayerische Staatsgemäldesammlungen

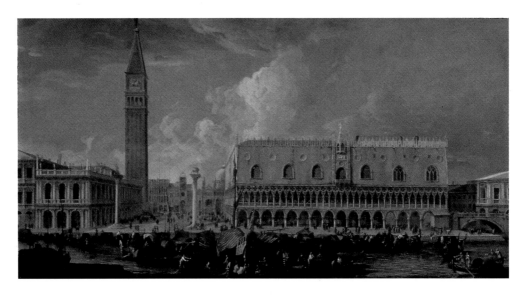

17. *Luca Carlevarijs*
View of the Wharf from the Bacino di S. Marco
85.7x163.8 cm
Montecarlo, private collection

18. *Luca Carlevarijs*
The Piazzetta and the Library
46x39 cm
Oxford, Ashmolean Museum

ner of the Venetian conception of the *veduta*: not as a faithful reproduction of reality, but almost as an assemblage of architectural elements. In fact, in the canvases of Canaletto, Bellotto, Marieschi, and Francesco Guardi, it is not "truthfulness" that we should be looking for, the perfect reproduction of reality as it appeared to their eyes: in a word the *photographic view*. For this we have to go instead to the work of the cartographers, such as the invaluable survey carried out by Lodovico Ughi on the basis of scientific measurements and printed in 1729. The painters — and in this sense the example of Richter is a particularly important one — saw Venice "with their own eyes," and this was how they depicted the city, through the filter of their own sensibility and culture and without feeling obliged to reproduce reality exactly.

There was another Northern European painter who dedicated himself, though only sporadically, to the *veduta* of Venice in the early decades of the eighteenth century: Antonio Stom (1688-1734), who painted a series of ornamental panels originally located over the doors of Palazzo Priuli at Piove di Sacco and then in a private collection in Bologna. They depict Venetian festivals (*The Regatta, The Festival of the Sensa; Fight on the Bridge of Fists; The Bull Hunt; The Place of Assembly; The Meeting*) and a few *vedute* in which he blends the style of Joseph Heintz the Younger with Carlevarijs's taste for small figures. The *View of Piazza S. Marco* from a window of the Procuratie Vecchie is particularly interesting, not only for its unusual point of view but also for the cool palette of colors, of grayish tone, laid down in thick brush strokes, and the lively

rendering of the figures in the foreground, of far higher quality than the static and vague ones sketched in the background. Yet it also reveals Tonino's limited grasp of perspective, especially obvious in the incorrect angle given to the facade of the Doge's Palace on the Piazzetta and the unconvincing detail of the island of San Giorgio Maggiore in the background.

The work of Bernardo Canal (Venice 1664-1744), father of the much more famous Antonio, known as Canaletto, is also very similar to the style of Carlevarijs. Bernardo achieved his greatest successes in the field of theatrical scene painting, in which he was assisted by his sons Antonio and Cristoforo, but he did not disdain the painting of *vedute*. There are few works that we can be certain are his, no more than a group of five canvases datable to 1734, one of them signed, in a private collection, and another two, signed and dated 1737, that have recently appeared on the antiquarian market, based on two of the engravings that Visentini had made from paintings by Canaletto. Recently a few other *vedute* have been grouped with these by critics, on the basis of stylistic similarities.

The fact that the few works certainly by Bernardo all date from the fourth decade of the eighteenth century suggests that he started painting *vedute* when already an old man, probably spurred on by the success of his son. And yet his works do not take the pictures of Antonio as a model, but those of the now dead — and surpassed — Carlevarijs, from whom they derive their rosy atmosphere, lively small figures, and even the characteristic way of arranging the clouds in the sky in order to confer depth of perspective on the scene.

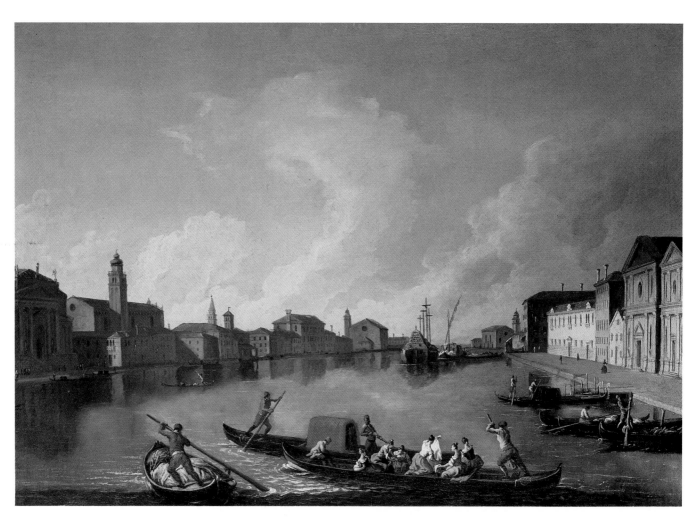

19, 20. Johann Richter
View of the Giudecca
Canal
60x80 cm
Milan, private collection

21. Antonio Stom
*View of Piazza S. Marco from
the Procuratie Vecchie*
106x123 cm
Private collection

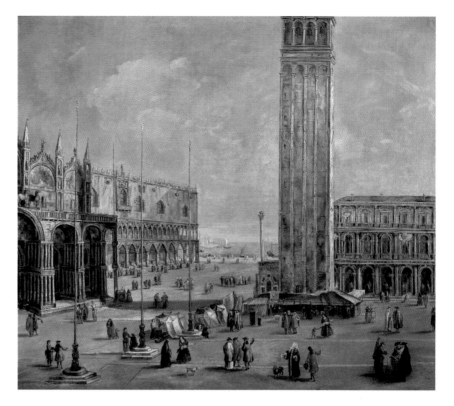

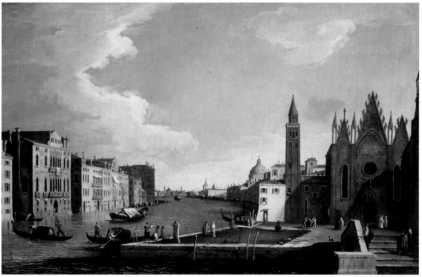

22. Bernardo Canal
*The Grand Canal with the Church
of La Carità*
70x120 cm
*Bassano del Grappa, private
collection*

23. Bernardo Canal
*The Grand Canal with the
Fabbriche Nuove at Rialto*
70x120 cm
*Bassano del Grappa, private
collection*

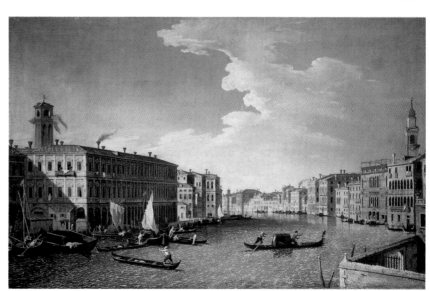

Canaletto

As has already been said, Canaletto — Zuanne Antonio Canal, born in the Venetian parish of San Lio on October 28, 1697 — commenced his artistic career as a painter of scenes for the theater. The oldest of these, produced from 1716 onward, were made for the Venetian theaters of Sant'Angelo and San Cassiano. In 1719 Bernardo and Antonio were in Rome, where they had gone to work on the sets of Alessandro Scarlatti's *Tito Sempronio Gracco* and *Turno Aricinio*, staged at the Teatro Capranica during the Carnival of 1720. It was in Rome, if we are to believe the account of Anton Maria Zanetti (1771), that the young Canaletto started to move in a new direction and, having "left the theater, weary of the intrusiveness of dramatic poets, gave himself up totally to painting *vedute* from life." "This was," adds Zanetti, "around the year 1719, in which he solemnly repudiated, as he put it, the theater." The extremely reliable testimony of the eighteenth-century historian has been interpreted in various ways, and some have pictured the young and ignorant artist suddenly discovering, through his encounter with the works of such Roman *veduta* painters as Codazzi, Panini, or Van Wittel, the new world of the *veduta* and, one is tempted to say, romantically immersing himself in it.

It is likely, however, that things took a different course and that Canaletto's move from scene painting to the *veduta* occurred in a more or less natural way. While it is possible, in fact, that at the start of his career Bernardo worked in the baroque style of the Bibiena family tradition, it is also true that a new type of scene painting emerged in the early years of the eighteenth century, in Venice as well as in Turin and Rome: a style that could be described as "pictorial" in contrast to that of the Bibiena, based on "perspective." In practice this meant no more fantastic and absurd baroque sets, no more exaggerated forms and strange fantasies with endless vistas of colonnades, monumental heap of architecture, and a profusion of decorative elements, but scenes that were largely confined to the backdrop, with themes linked to the painting of ruins and landscapes.

Most of the credit for introducing this new style to Venice must be given to Marco Ricci. The painter had dedicated part of his career to stage scenery, with some

24, 25. Canaletto
Grand Canal: looking East from the Campo S. Vio
140.5x204.5 cm
Madrid, Thyssen Bornemisza Collection

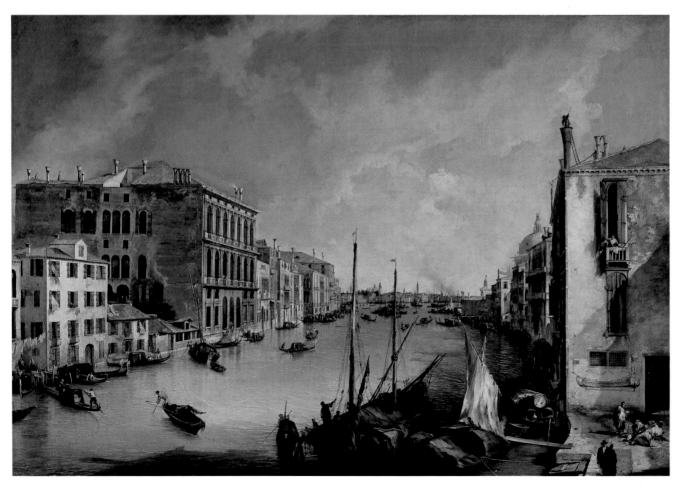

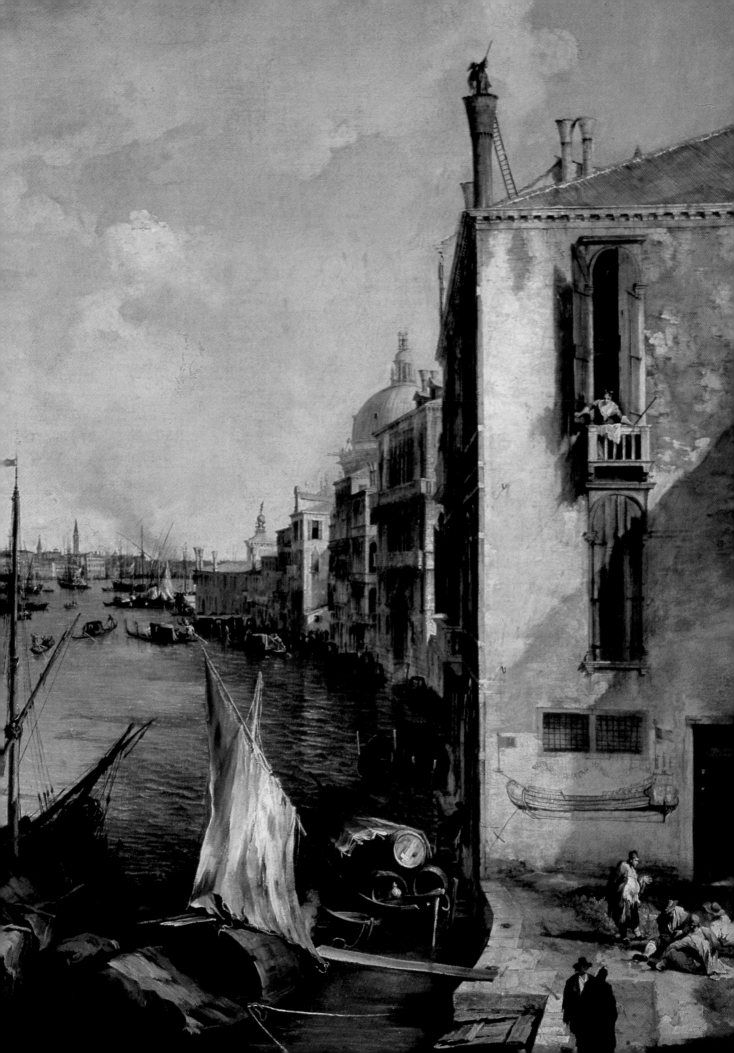

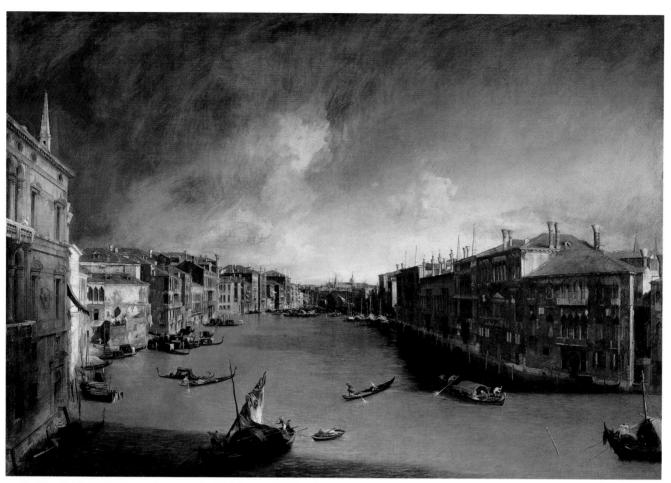

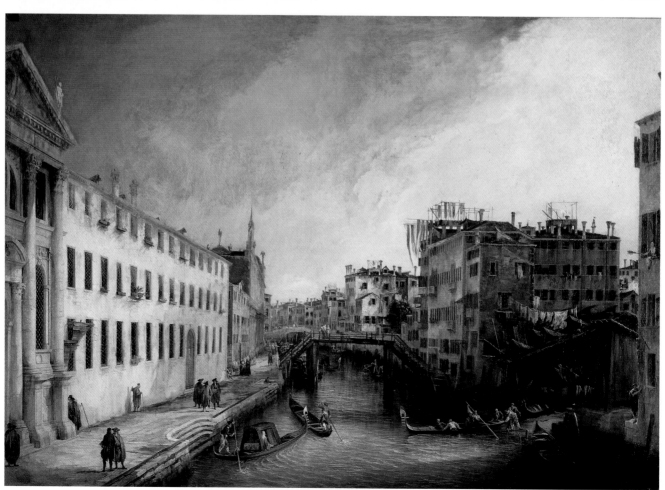

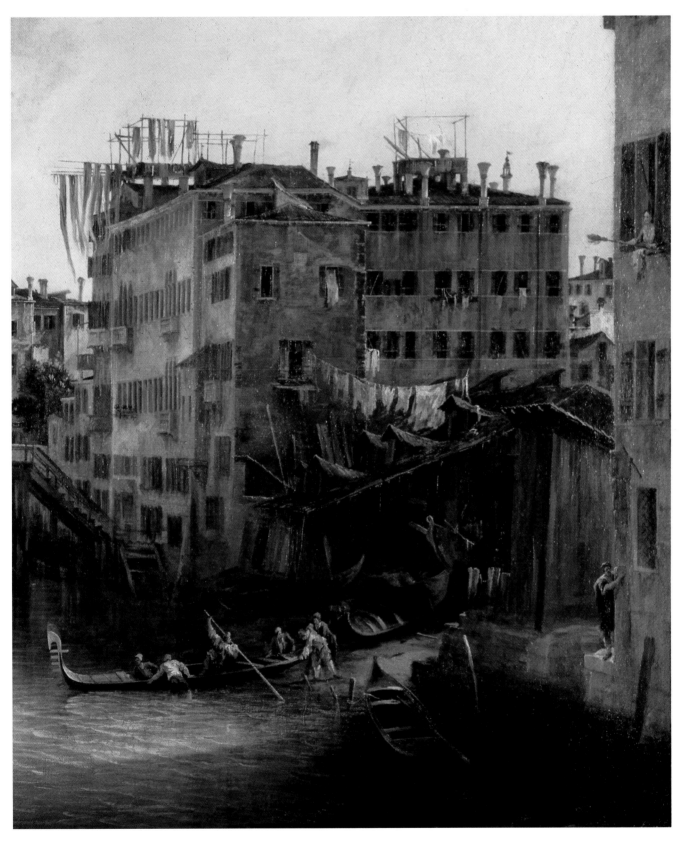

26. Canaletto
Grand Canal: looking Northeast from Palazzo Balbi
toward the Rialto Bridge
144x207 cm
Venice, Ca' Rezzonico

27, 28. Canaletto
Rio dei Mendicanti
143x200 cm
Venice, Ca' Rezzonico

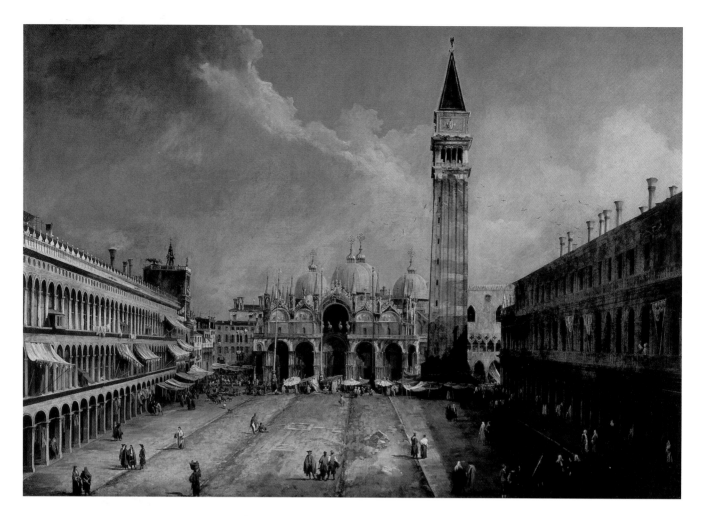

29. *Canaletto*
Piazza S. Marco
140.5x204.5 cm
Madrid, Thyssen Bornemisza Collection

success if it is true that the main purpose behind his first visit to England, made in the company of Giannantonio Pellegrini between 1708 and 1712, was to participate in the staging of Italian operas at the King's Theatre in the Haymarket. Subsequently, in 1716, Ricci resumed this activity in Venice and, two years later, took over the job of painting scenes at the Teatro Sant'Angelo from the Canal family.

We know little of Marco's activity in this field. However the fifty odd stage designs now in the Royal Library at Windsor Castle — dating from his last stay in Venice and coming from the collection of the British consul Smith — provide us with an excellent picture of how he used the same figurative and thematic repertory in his set designs as he did in his paintings: large squares with arcades, vistas of colonnades and courts, prisons, huge parks, and spacious frescoed rooms, glimpsed through a series of arches decorated with historical scenes. So it seems reasonable to assume that the young scene painter Canaletto would have been interested in the innovations brought about by his more established colleague and that his sets — of which unfortunately nothing has survived — were in some ways similar to Marco's. Support for this hypothesis comes from an examination of Canaletto's earliest pictures, the *Capricci* in private collections in Venice, Milan and Switzerland and in the Wadsworth Atheneum in Hartford.

In fact the scenic layout and dense, glowing tones of color that appear in these paintings are a clear testimony to the effect that Ricci's work had on the young artist. The influence of the painter from Belluno is also apparent in Canaletto's very first *vedute* of Venice, the four large canvases that were owned by the prince of Liechtenstein in Vienna at the end of the eighteenth century and are now split equally between the Thyssen collection in Madrid and the Venetian Museo del Settecento in Ca' Rezzonico. It is highly likely, in my view, that the four *vedute* were not painted at the same time, but in groups of two at different moments, several years apart. In fact in the *Gran Canal: looking East from the Campo S. Vio* in the Thyssen collection we can see the scaffolding that was mounted on the dome of the church of La Salute in September 1719 in order for consolidation work to be carried out, while the *Piazza S. Marco: looking East along the Central Line* in the same collection shows the area at a time when the new paving designed by Andrea Tirali was being

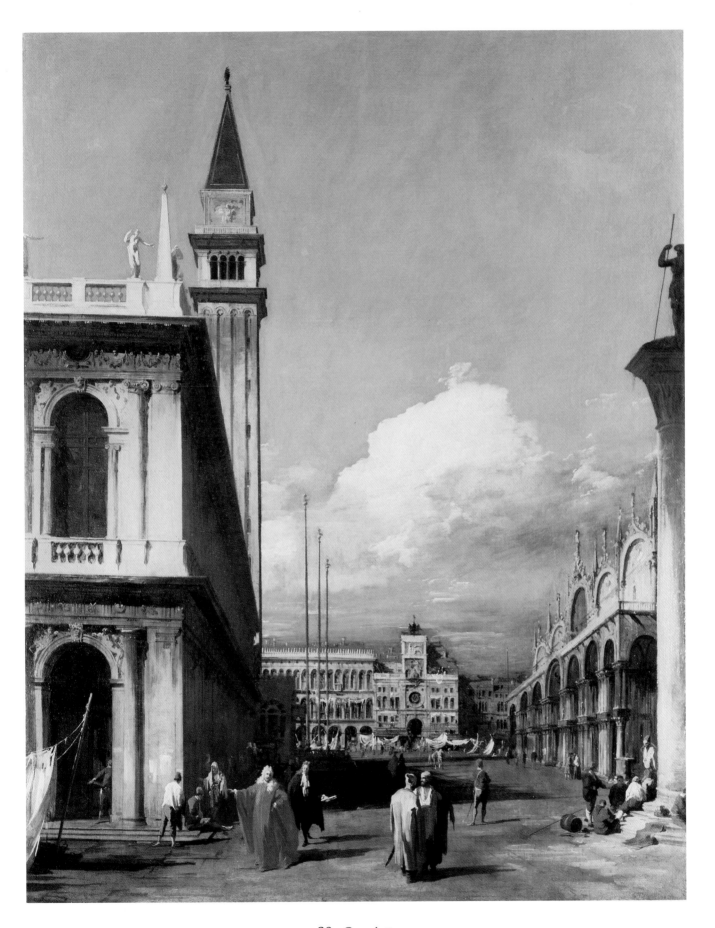

30. Canaletto
The Piazzetta: looking toward the Clock Tower
172x135 cm
Windsor Castle, Royal Collections

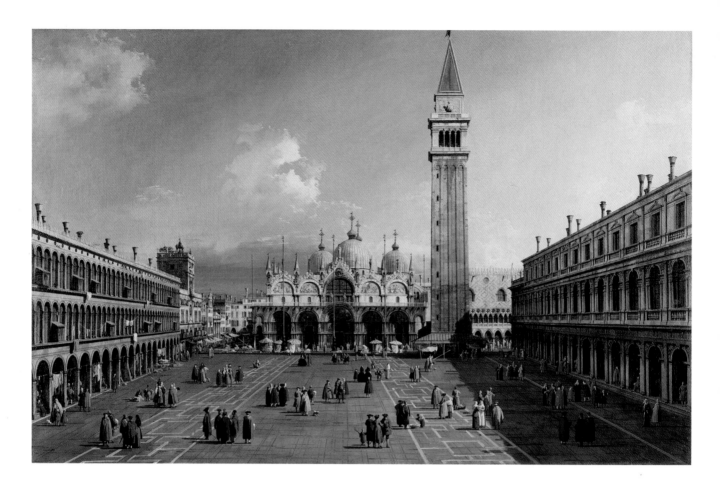

laid, in the state in which, according to the records, it must have been in 1724.

Above all, however, the four paintings are not perfectly homogeneous from the stylistic point of view, and it seems to me that it is possible to use them to trace the development of the early phase of Canaletto's style. In the *Grand Canal: looking Northeast from Palazzo Balbi toward the Rialto Bridge* in Ca' Rezzonico, the brownish tones typical of Ricci's paintings are clearly visible. The figures are small and fairly imprecise, but caught in extremely lively positions. In addition, Canaletto makes use here of an *escamotage* that probably derives from the tradition of set design, using two different sources of light in the foreground so that the shadows of both Palazzo Balbi, on the left bank, and those of the houses of the Mocenigo, on the right bank, are cast onto the waters of the Grand Canal. The *veduta* of the *Rio dei Mendicanti* in the same Venetian museum, on the other hand, is far more luminous and brighter in its coloring. The figures are noticeably larger in proportion to the buildings and each of them is depicted with precision and in rich detail.

It appears, therefore, that in the brief space of two or three years that separates the execution of these two pairs of paintings, Canaletto's style underwent a distinct modification, moving in the direction of a better relationship with reality. On the other hand, it seems possible to discern in the *Rio dei Mendicanti* and the contemporary *Piazza S. Marco* the first glimmerings of

31. Canaletto
Piazza S. Marco with the Basilica
76x114.5 cm
Cambridge (Massachusetts), Fogg Art Museum

the research that was to lead the painter, over the course of the second half of the seventeen twenties, to that "conquest of light" that was to characterize his subsequent production. And, significantly, this took place at the same time as that other great protagonist of Venetian painting in the eighteenth century, Giambattista Tiepolo was developing his own style. From roughly the time when he executed the frescoes in Palazzo Sandi (1725), Tiepolo progressively abandoned the gloomy tones of the tradition of Piazzetta and Bencovich and started to produce paintings of ever greater luminosity, this time taking the works of the 16th-century Paolo Veronese as his model.

Canaletto's success in Venice must have been immediate, as his pictures soon began to supplant those of the established Carlevarijs on the shopping lists of collectors. Moschini (1806) states that Luca died of a broken heart when he saw that he had been surpassed by this new star of Venetian *veduta* painting. And while this is not in fact true, the comment does offer a convincing confirmation of the rapid rise of the young artist.

The reasons for his popularity with his contemporaries become apparent if we read the letters that were ex-

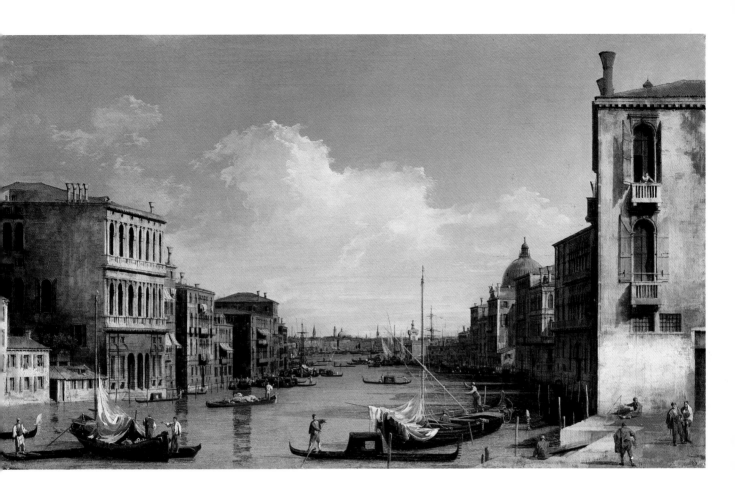

32. Canaletto
Grand Canal: looking toward the Church of La
Salute from the Campo S.Vio
46x77.5 cm
Windsor Castle, Royal Collections

changed in 1725-6 between the painter Alessandro Marchesini, a native of Verona but resident in Venice, and the merchant and collector Stefano Conti of Lucca. The latter had asked Marchesini — who combined his work as a painter of historical and religious pictures with the role of an intermediary between his colleagues and collectors — to procure for him two *vedute* of Venice, to go with the three by Carlevarijs that he already owned. In response to this request; Marchesini informed him that "Ser Lucca... is old now" and that his place had been taken by "Sig.r Ant. Canale, who universally astounds everyone in this town that sees his works, which are of the character of Carlevari but in them one sees Light inside the Sun." Thus Marchesini was pointing out the thematic continuity of Canaletto's paintings with those of Carlevarijs, but at the same time showing that he understood Antonio's desire to give the maximum of luminosity to his *vedute*. That Marchesini's enthusiasm made an impression on the collector is proved by the fact that Conti purchased from Canaletto — notwithstanding the difficulties that arose from the painter's already numerous commitments and the high price of the works — not two but four *vedute*.

The canvases acquired by Conti are now in the collection of the Hosmer heirs in Montreal. The preparatory drawing for one of them, depicting the *Rialto Bridge*, the first to have been painted, still exists and is in the Ashmolean Museum in Oxford. This drawing made from life (it was not for nothing that Marchesini had written to Conti that Canaletto "always goes to the place, and fashions everything from life") is of great interest, as it shows the attention that the painter paid to the representation of light, underlined by the word "sun" written in ink in the part of the *veduta* where the incidence of light was strongest and most dazzling. This brightness was transferred faithfully from the drawing to the painting, further proof of Canaletto's interest in the realistic rendering of natural light.

However the paintings for Stefano Conti, characterized by their free and dense brushwork, had not yet achieved the peaks of luminosity that were to connote Canaletto's *vedute* in the late twenties. Rather they show a marked contrast of chiaroscuro between shaded and sunlit areas, a legacy of the influence of Ricci which is a feature of Antonio's early works.

The next and, one is inclined to say, definitive step came immediately after he had finished the work for Conti, when Canaletto came into contact with the Irishman Owen McSwiney, a failed theatrical impresario who had been forced to leave England. At first McSwiney convinced Canaletto to collaborate — together with Pittoni, Cimaroli, and Piazzetta — on the execution of

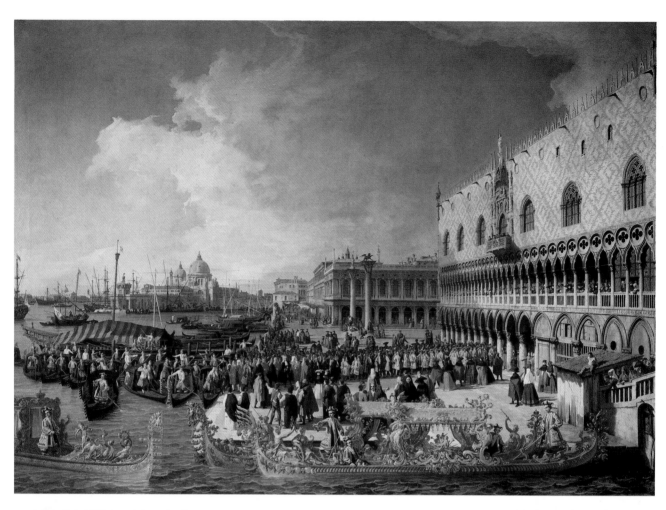

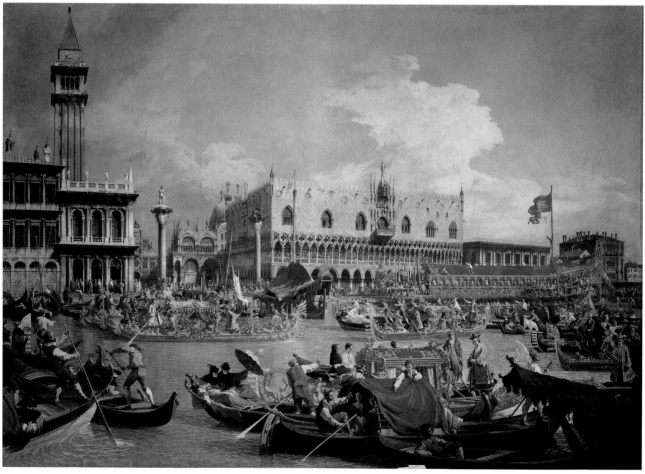

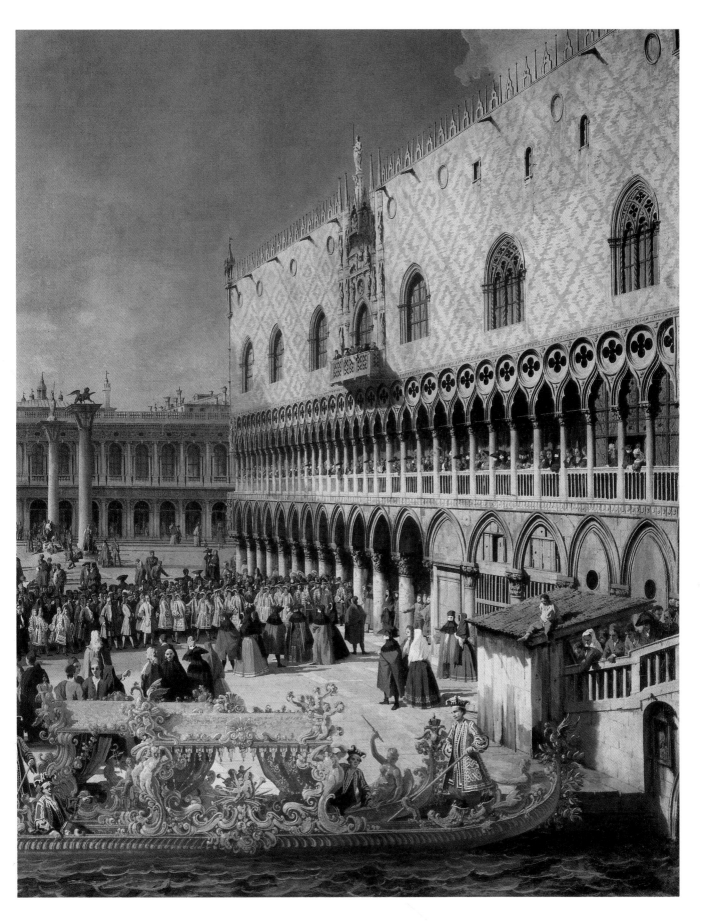

33, 35. Canaletto
*The Reception of the Ambassador in the Doge's
Palace; 184x265 cm
Milan, Crespi Collection*

34. Canaletto
*The Bucintoro Returning to the Molo on Ascension
Day; 182x259 cm
Milan, Crespi Collection*

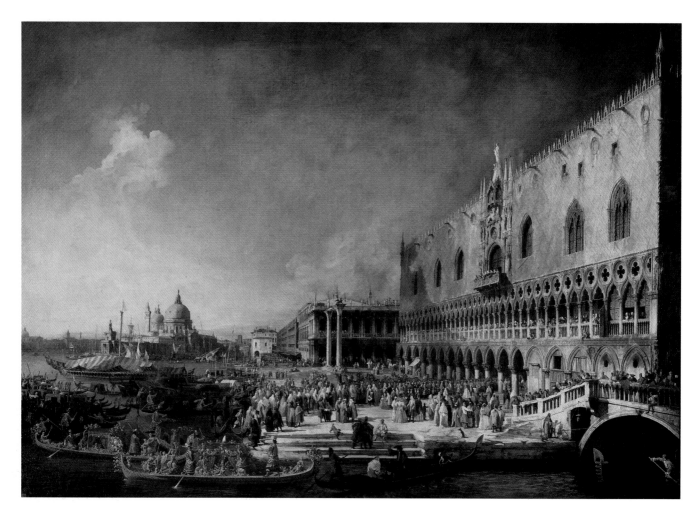

two *Allegorical Tombs* that were to be part of a series of imaginary monuments dedicated to illustrious figures in the history of late seventeenth-century Britain, entrusted to the most celebrated artists of the Bolognese and Venetian schools. At the same time, however, he persuaded him to produce two small *vedute* on copper for the Duke of Richmond, who had also been the client for the *Tombs*.

In these small works, sent to England in 1727, Canaletto abandoned the dramatic style and strong chiaroscuro of his juvenile phase and embarked on an intense luminosity that placed the emphasis on the details of the *veduta* and of the works of architecture of which it was made up. The extent to which McSwiney's advice influenced this new shift is hard to tell, but one gets the impression that the go-between's desire to obtain works more in keeping with the taste of British buyers, and therefore more precise in their topography and accurate in their pictorial representation, was perfectly in harmony with the painter's own desires, and merely accelerated a process that was already under way. Moreover, it was in just these years that Newton's scientific theories on light and its breakdown into separate colors on the one hand, and on the absolute nature of space on the other, started to become familiar in Venice. And the hypothesis of those who claim that the young painter may have come into contact with and appreciat-

36. Canaletto
The Arrival of the French Ambassador in the
Doge's Palace
181x259 cm
St. Petersburg, Ermitage

ed the revolutionary discoveries that were coming out of England appears highly credible.

In the meanwhile, the collaboration between Canaletto and McSwiney was coming to an end. In 1730 the impresario was already complaining to the Duke of Richmond that the painter was late in delivering two more paintings on copper ordered by the illustrious client. This negligence on the part of Canaletto may have been the consequence of his new relationship with the intermediary who was going to launch his career in a definitive manner, Joseph Smith. Banker, merchant, and a man of considerable culture and broad interests, Smith was a collector of the highest caliber. In addition he provided a point of reference, in part through his role as British consul in Venice (a post that he held uninterruptedly from 1744 until his death), for the English aristocracy that came to the city on the Grand Tour or for reasons of business.

Smith and Canaletto quickly formed a close relationship, and it was through the former that the painter obtained the majority of his profitable commissions from

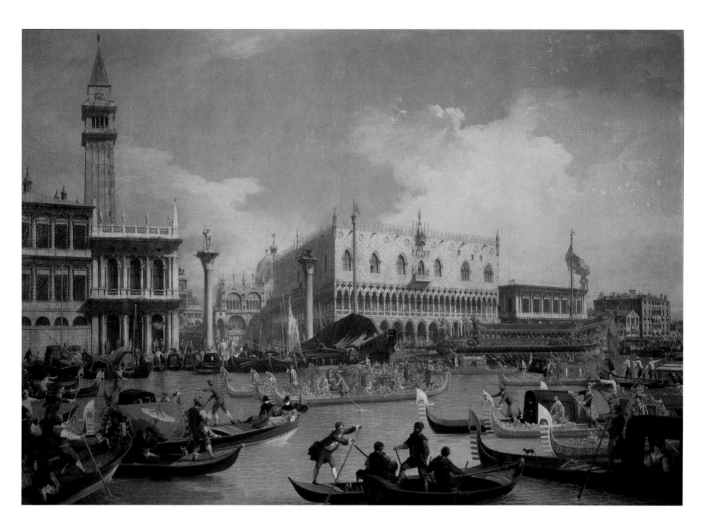

37. Canaletto
The Bucintoro Returning to the Molo on Ascension Day
187x259 cm
Moscow, Pushkin Museum

British clients. Canaletto also painted numerous pictures for Smith himself: when the consul sold his own art collection to George III of England in 1762, fifty paintings by the Venetian master arrived at Windsor, together with over a hundred and fifty drawings.

The first canvases he painted for Smith were six fairly large views of St Mark's Square and the surrounding area. On the basis of details of topography, these can be dated to between 1726 and 1728, that is to say around the same time as the execution of the two paintings on copper for the Duke of Richmond. In comparison with these, the canvases now in Windsor are closer to his juvenile style in their brownish tones and dense brushwork, together with a fleeting interest in figures of a large size. The works that followed immediately afterwards, though, were completely different. Canaletto started to paint a Venice flooded with sunlight: an animated, luminous city, whose details were depicted with great care. This change is evident not only in the twelve of Smith's canvases now in Windsor that can be dated to 1730 or before, but also in the *vedute* of *Piaz-*

za S. Marco with the Clock Tower in Kansas City, the *Entrance to the Grand Canal* in Houston, and the *Piazza S. Marco with the Basilica* in Cambridge.

In any case Canaletto's *vedute* cannot be described as "photographic": the painter used several different points of view in a single work, adjusting reality to suit his own needs and his own poetics. Marchesini's comment ("he paints on the spot and not from imagination at home as does Ser Lucca") was not only unfair to Carlevarijs, for the claim was untrue, but misleading if it gives us the idea that Antonio used to take his canvases, easel, paints, and all the rest to the chosen location and paint there what he saw. What the artist did in fact was make sketches on the spot — with the aid of the camera obscura — and then paint his pictures from these in the studio.

An exceptional example of this *modus operandi* is provided by the so-called *Quaderno Cagnola* in the Galleries of the Academy of Venice, which contains numerous pencil sketches made "on the spot" and later inked over. These sketches, which bear a series of written notes that were sometimes used to identify the site for later inclusion in the painting ("Campo S.M.a shapely first part / on the left looking toward the church"), and at others provided information about colors or particular situations ("dirty"), were then put together on the canvas to compose the *veduta*. Obvi-

31

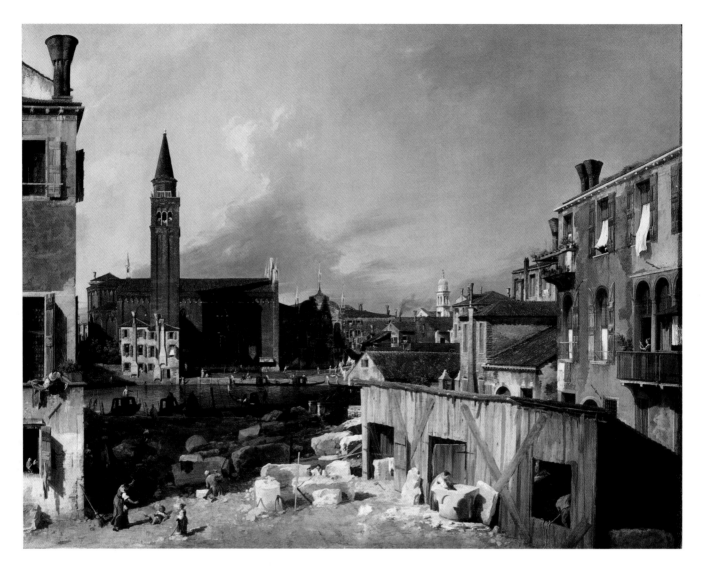

ously the individual points of view were retained and did not always coincide. This procedure is part of the reason for certain distortions of perspective and unnatural enlargements that become apparent on careful examination of Canaletto's *vedute*. At the same time it has to be remembered that these views are the product of the creative genius of an artist who was not necessarily interested in the perfect reproduction of reality. As a result there were times when he altered — one is tempted to say "capriciously" — certain aspects of what he saw.

So Canaletto's *vedute* constitute a fairly curious case: the combination of a number of exact reproductions — the ones in the *Quaderno Cagnola* that is — produces pictures that do not wholly correspond to reality. This explains why there has been such a fierce debate among critics over the presumed "realism" of Canaletto, considered by some almost as a forerunner of photography — it has been said that his *vedute* are distinguished by "an absolute sense of reality" — while others, more correctly, hold that what Canaletto was actually doing was to "seek the impression of reality."

As has already been mentioned, the works that he painted for Smith up to 1730 form a homogeneous

38, 39. Canaletto
The Stonemason's Yard
124x163 cm
London, National Gallery

group of twelve views of the Grand Canal. They were hung in Smith's own residence at Santi Apostoli, which looked onto the Grand Canal: this was the house known as Palazzo Balbi-Mangilli-Valmarana, which the future consul was to have rebuilt in a classical style by Antonio Visentini between 1740 and 1751.

The canvases came to represent a sort of collection of samples for potential buyers who stayed in Smith's home. Indeed, in order to make the paintings known to the largest possible number of connoisseurs, Smith had Visentini make engravings from the *vedute*, together with two more pictures by Canaletto depicting *A Regatta on the Grand Canal* and *The Bucintoro at the Molo on Ascension Day*, painted in 1734. The collection of reproductions of the fourteen *vedute* was published in 1735 under the title *Prospectus Magni Canalis Venetiarum*. The venture proved so successful that Smith decided to publish another edition, seven

32

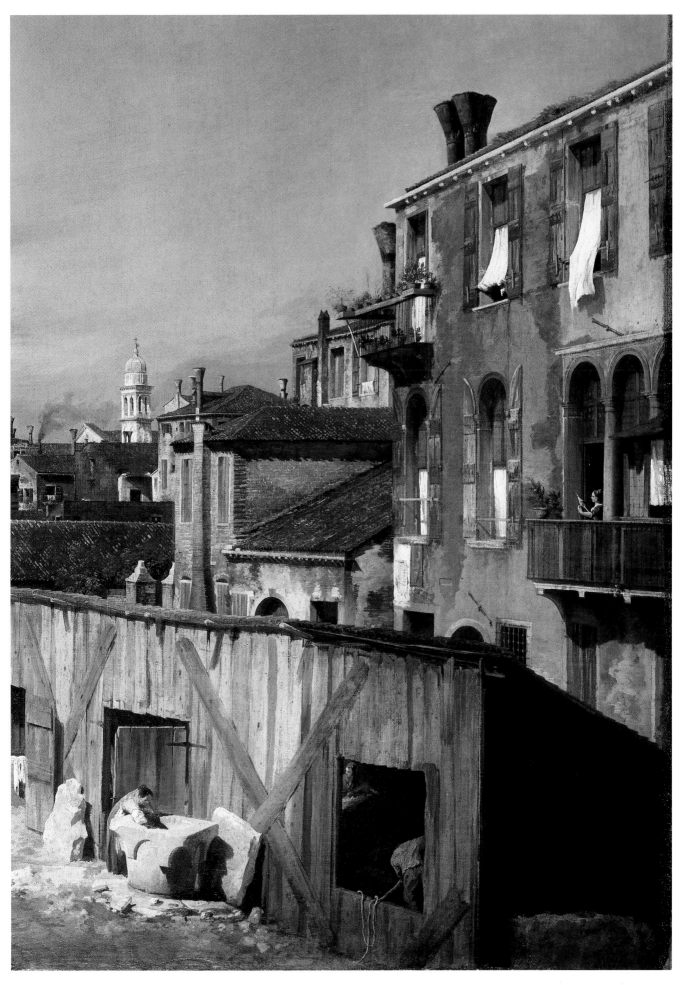

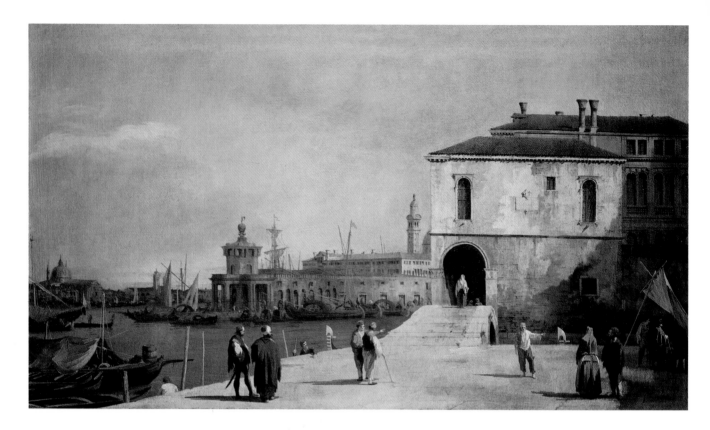

years later, with the addition of a further twenty-four of Visentini's engravings from Canaletto's paintings, and the publicity must have been effective, since Canaletto made several replicas of the paintings for different buyers.

At the same time as this series for Smith, Canaletto painted some canvases for the Imperial ambassador to the Republic of Venice, Count Bolagnos, who wanted a record of the ceremony of the presentation of his credentials to the doge, which took place on May 29, 1729. Consequently the two paintings, now in private collections, must have been painted after this date. The first of them depicts the *Reception of the Ambassador in the Doge's Palace* and is based on similar subjects painted by Carlevarijs. It most closely resembles the *Reception of the Count of Colloredo* now in Dresden (1726), from which Canaletto took the scenic layout, but differs from it in the clarity of light and brightness of color. The second represents *The Bucintoro Returning to the Molo on Ascension Day* and must be considered one of Canaletto's highest achievements. The painting is limpid and drenched with light, and the brushwork is fluid and precise in its description of the tiniest details of the boats and the lively small figures that make up the gaily colored procession waiting to follow the doge's ship to San Nicolò del Lido.

It is a matter of debate whether these paintings constitute Canaletto's first venture into the specific field of the representation of public ceremonies, or had been preceded by pictures of similar subjects painted to commemorate the reception of the French ambassador Jacques-Vincent Lanquet, Count of Gergy, on Novem-

40, 41. Canaletto
The Fonteghetto della Farina
66x112 cm
Venice, private collection

ber 4, 1726. In fact the two canvases that have been identified as depicting this event, now in the Hermitage in St Petersburg and the Pushkin Museum in Moscow, can certainly be dated, on the basis of objective comparisons, to the same period as the *vedute* commissioned from Count Bolagnos. Hence we must conclude that they are updated replicas, certainly painted by Canaletto himself given their high quality, of the canvases executed in 1726 for the Count of Gergy — mentioned as already finished in the Marchesini-Conti correspondence — and subsequently lost.

A number of other superb masterpieces can be dated to the years between the end of the third and the beginning of the fourth decade of the century. They include *The Stonemason's Yard* in the National Gallery in London, formerly the property of Sir George Beaumont, which depicts stonemasons at work in the Campo di San Vidal in dazzling sunlight and, on the other side of the Grand Canal, over which the bridge had not yet been built, the buildings of the Scuola and the church of Santa Maria della Carità, still flanked by the slender campanile that collapsed in 1741. The *Fonteghetto della Farina* (Flour Warehouse) in a private collection in Venice dates from the same time and was probably painted for the Venetian man of letters and bibliophile Giovan Battista Recanati. It depicts, in an image of ex-

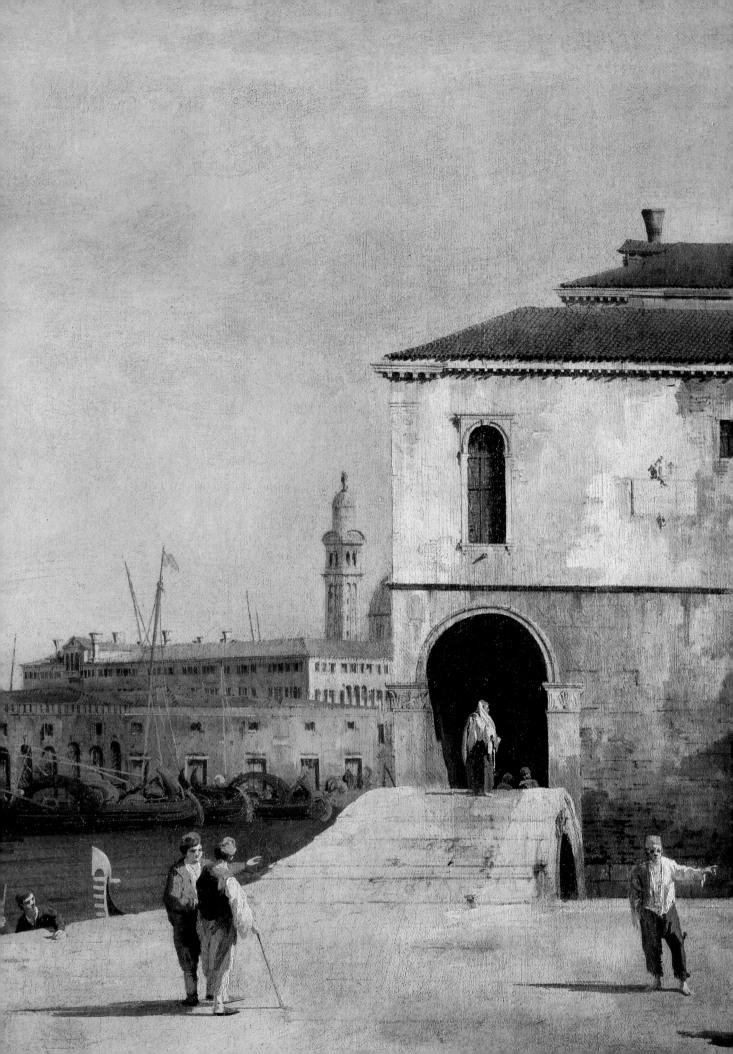

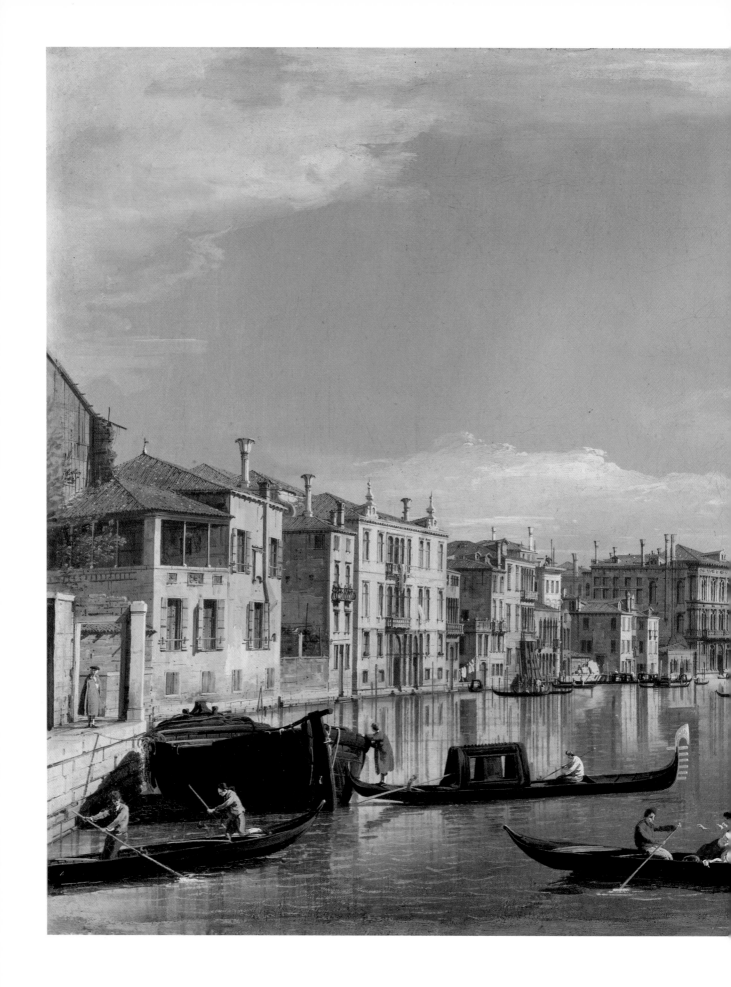

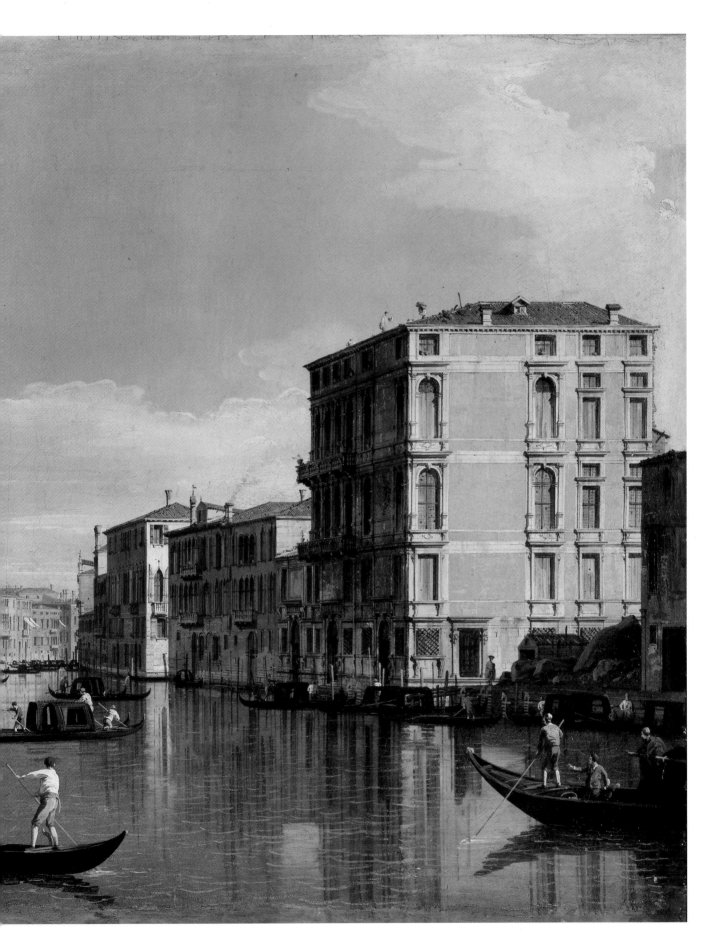

42. Canaletto
The Grand Canal between Palazzo Bembo and Palazzo Vendramin Calergi; 47x80 cm
Woburn Abbey, private collection

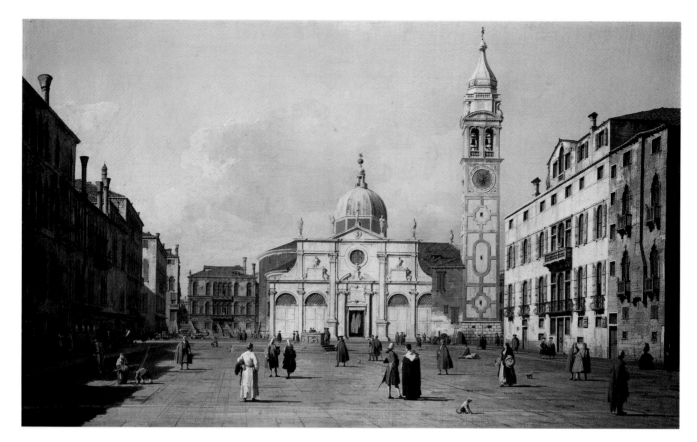

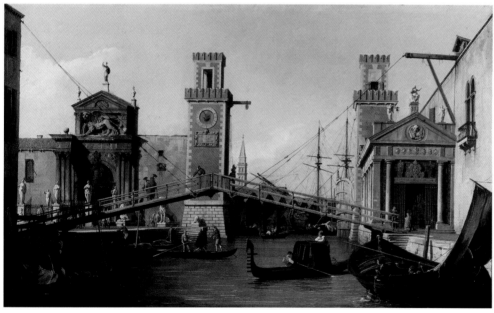

43. Canaletto
*Campo Santa Maria
Formosa*
47x80 cm
Woburn Abbey, private
collection

44. Canaletto
*View of the Entrance
to the Arsenal*
47x78 cm
Woburn Abbey, private
collection

traordinary luminosity, the building that was to become — in 1750 — the first seat of the Academy of Painting and Sculpture (and which now houses the Harbor Office of Venice). The picture is of considerable topographic interest, since it shows a site that underwent profound alterations in the early nineteenth century, when the elegant Coffee House designed by Lorenzo Santi was built and the bridge that used to lead over the Rio della Luna and through the arches under the Fonteghetto to Calle Vallaresso was dismantled, isolating the area of St Mark's from that of San Moisè. It was not until later that the narrow street along the canal was created, served by a new bridge set further to the left with respect to the Fonteghetto.

In the thirties Canaletto received many more commissions from Great Britain: these included twenty-two *vedute* for the Duke of Bedford, now in Woburn Abbey, four for William Holbech at Farnborough Hall, dispersed in 1930, six for Francis Scott, the second Duke of Buccleuch, reproducing subjects already painted in the canvases for Smith, and seventeen for the Earl of Carlisle at Castle Howard, some of which were sold after the Second World War. The *vedute* painted for the Duke of Bedford, datable to no later than 1735,

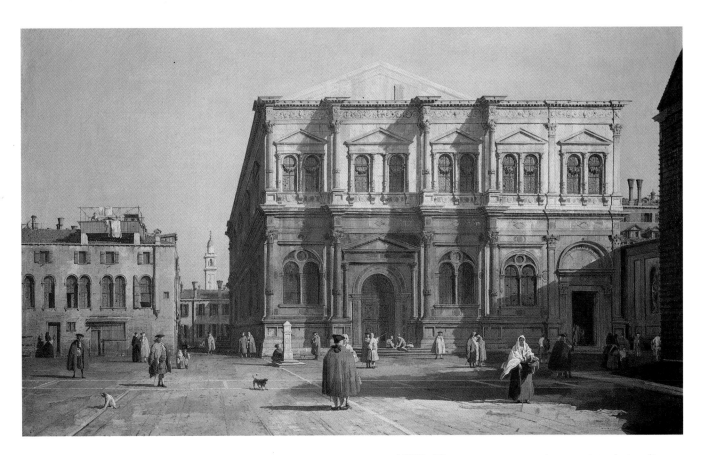

45. *Canaletto*
Campo San Rocco
47x80 cm
Woburn Abbey, private collection

reproduce the most famous sights of Venice, from St Mark's Square to the Grand Canal, though a few of these are devoted to less well-known locations. Among the latter should be counted the limpid *View of the Entrance to the Arsenal* which shows, to the right of the canal leading to the shipyard, the 16th-century Oratory of the Madonna, demolished by the French in 1809; that of *Campo Santa Maria Formosa*, with Codussi's church forming the pivot of a scenic *veduta* that unnaturally enlarges the actual space; and the one depicting *Campo San Rocco*, where the 16th-century facade of the Scuola made famous by Tintoretto's cycle of paintings performs the same function as Codussi's church in the previous *veduta*.

It is not certain whether the paintings that were sent to Castle Howard in the early eighteenth century were commissioned by the third Earl of Carlisle, Charles Howard, who employed such Venetian artists as Jacopo Amigoni, Giannantonio Pellegrini, and Marco Ricci on the decoration of his stately home, or his son, the fourth Earl. The numerous works that once hung in the residence of the Earls of Carlisle included some of the artist's greatest masterpieces, and in particular the extraordinary *Bacino di S. Marco: looking East*, which has been in the collection of the Museum of Fine Arts in Boston

since 1939. This panoramic *veduta*, painted simultaneously from several raised points of view in the vicinity of the promontory of the Customs, extends from the eastern end of Giudecca, on the right, to the Granaries of Terranova on the left. The unusually wide *veduta* is flooded with brilliant light. The waters of the basin are streaked by dozens of boats of every kind, thronged with numerous figures. The long line of buildings is depicted in detail, with great care, and the presence of the new campanile of the church of Sant'Antonin allows us to date the picture to 1738 with some confidence.

Other paintings that were originally in Castle Howard include the *vedute* of the *Basilica and Doge's Palace* and the *Entrance to the Grand Canal from the Bacino di S. Marco*, further splendid examples of Canaletto's mature style that are now in the National Gallery in Washington.

Another important group of Canaletto's works dating from the fourth decade is that of the twenty-one *vedute* acquired in Venice in the middle of the nineteenth century by the last Duke of Buckingham and Chandos. On the latter's death these were bequeathed to the Harvey collection at Langley Park and were dispersed in the fifties. Nine of them were engraved by Visentini and appear in the 1742 edition of the *Prospectus*: this suggests that they too may have been part of the Smith collection.

Many of the canvases that used to belong to Buckingham have come back to Italy and ten of them are in a private collection in Milan. They include several ex-

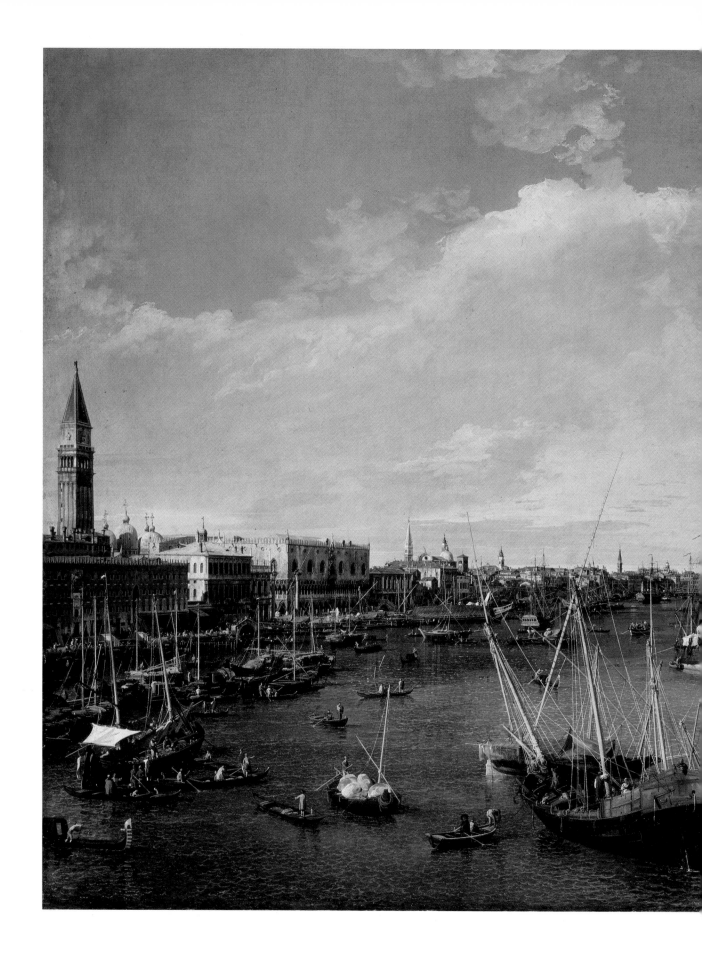

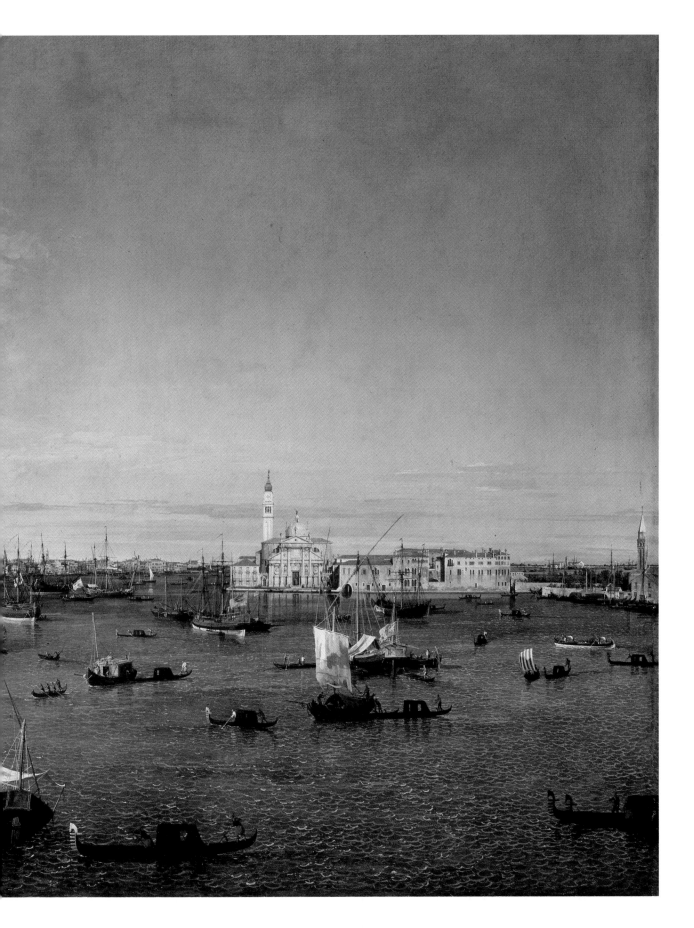

46. Canaletto
The Bacino di S. Marco: looking East
125x204 cm
Boston, Museum of Fine Arts

41

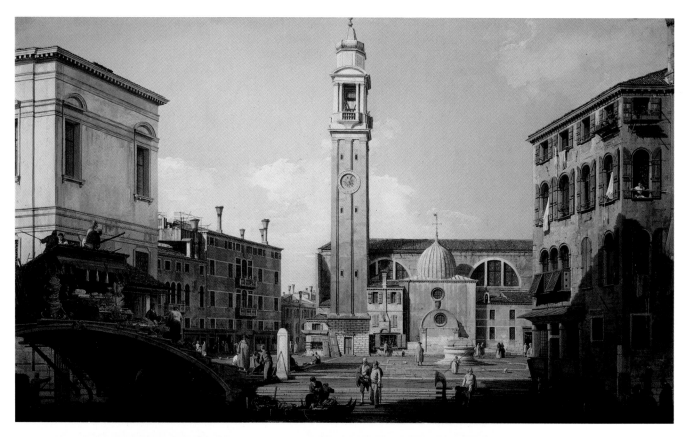

47, 48. Canaletto
*View of Campo Santi
Apostoli
45x77.5 cm
Milan, private collection*

49, 50. Canaletto
*View of San Giuseppe
di Castello
47.5x77.5 cm
Milan, private collection*

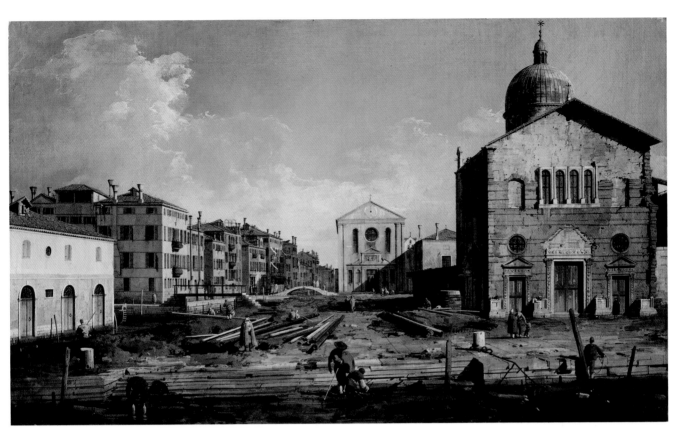

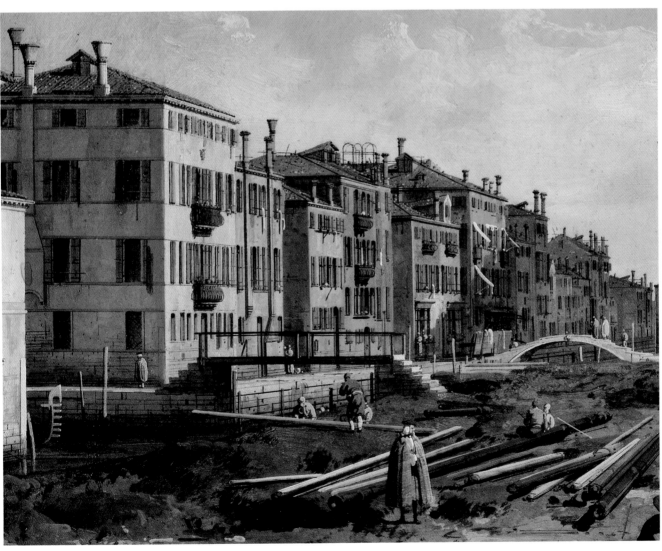

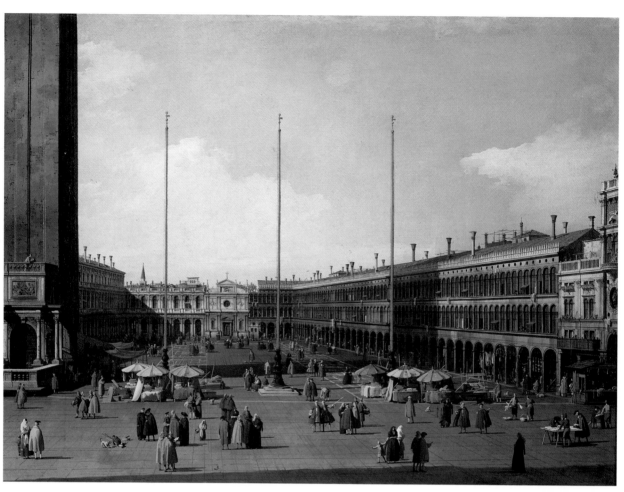

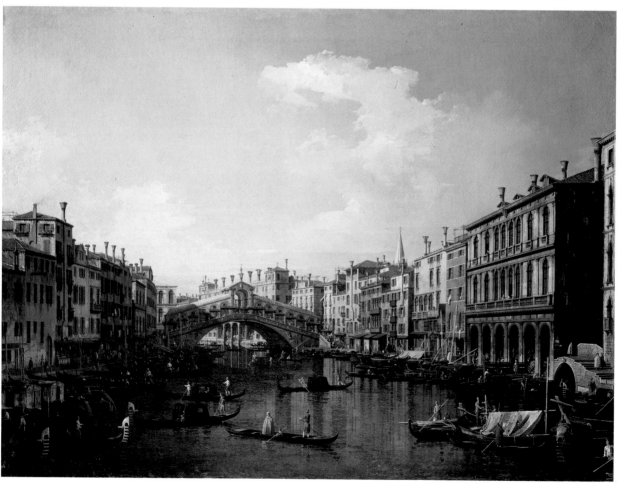

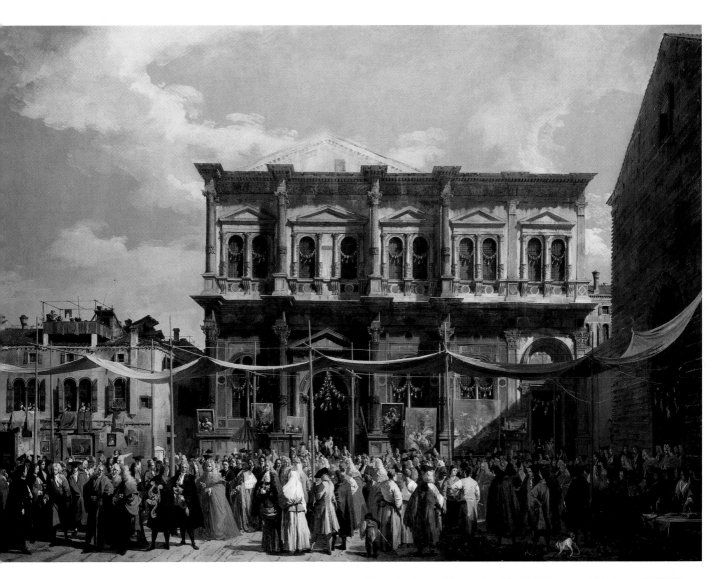

51. Canaletto
*Piazza S. Marco: looking
toward San Geminiano*
68.5x93.5 cm
Rome, Galleria Nazionale

52. Canaletto
*The Rialto Bridge: from the
South*
68.5x92 cm
Rome, Galleria Nazionale

53, 54. Canaletto
*The Doge visiting the Church
and Scuola di S.Rocco*
147x199 cm
London, National Gallery

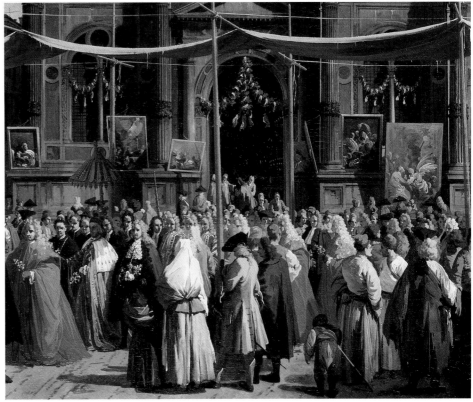

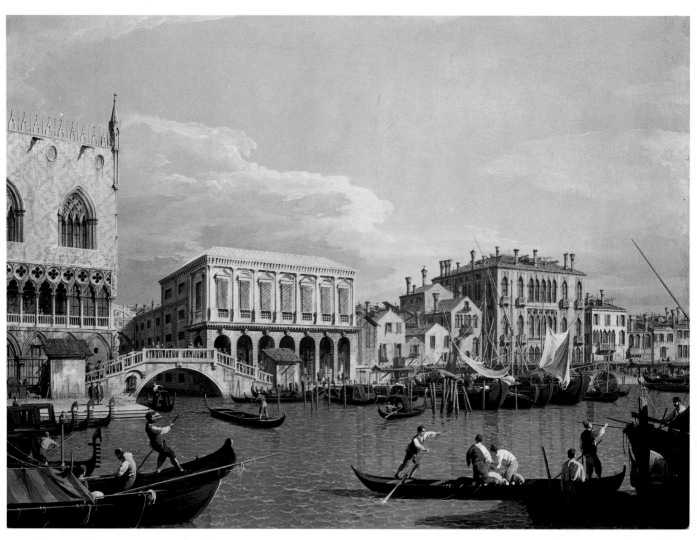

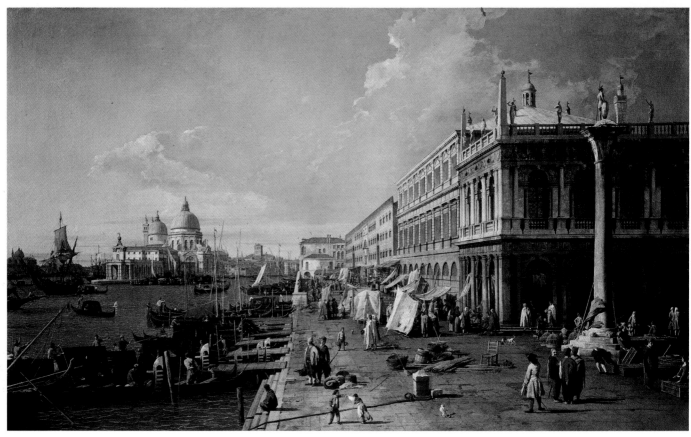

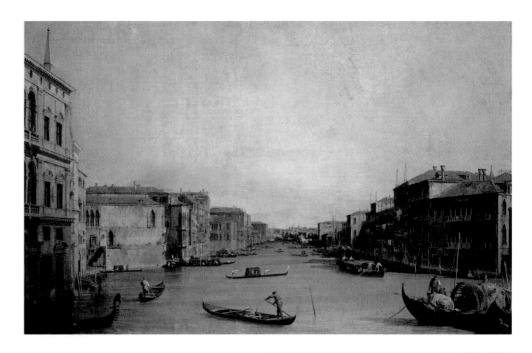

55. Canaletto
The Molo and the Riva degli Schiavoni: from the Bacino di S. Marco
46.5x63 cm
Toledo (Ohio), Museum of Art

56. Canaletto
The Molo with the Library and the Entrance to the Grand Canal
110.5x185.5 cm
Rome, private collection

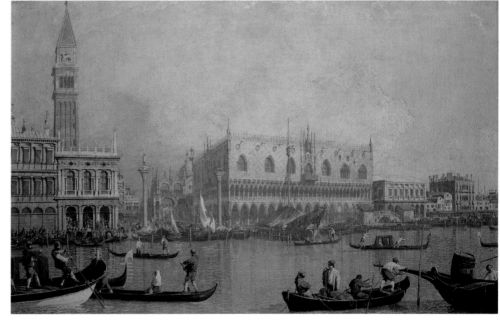

57. Canaletto
Grand Canal: from Palazzo Balbi
45x73 cm
Florence, Galleria degli Uffizi

58. Canaletto
View of the Doge's Palace
51x83 cm
Florence, Galleria degli Uffizi

ceptional masterpieces, such as the *View of Campo Santi Apostoli* dominated by the tall seventeenth-century campanile that already has the elegant belfry built at the beginning of the eighteenth century to a design by Andrea Tirali, and that of *San Giuseppe di Castello*, showing the buildings — including the ancient church dedicated to St Nicholas — that stood on the site where Giannantonio Selva laid out the Napoleonic Gardens in the early nineteenth century.

Other pictures that are very similar in style to the group once owned by Buckingham are the four limpid *vedute* in the Galleria Nazionale at Palazzo Corsini in Rome, representing the *Piazzetta looking toward the Basin*, *Piazza S. Marco looking toward San Geminiano*, the *Grand Canal: looking toward Ca' Foscari from the Rialto Bridge*, and the *Rialto Bridge: from the South*: all subjects that he had already tackled in his juvenile works,

but now depicted in an all-pervading and dazzling light.

In the middle of the fourth decade Canaletto painted another unquestioned masterpiece, *The Doge visiting the Church and Scuola di S. Rocco* in the National Gallery in London. The picture records the annual visit paid to the church of San Rocco by the doge on the saint's feast day — August 16 — a day when works by Venetian artists enroled in the Guild were put on show to the public in the square in front of the church. We do not know who commissioned the painting from Canaletto: the only clue that we have comes from the catalogue of an auction held in London in 1804, where the picture was described as coming "from the Vatican." This too is a *veduta* of exceptional luminosity, in which the figures of the doge, the ambassadors, and the senators are depicted with great clarity; the same is true of the architectural details, with even the hooks used

to hang the festoons clearly visible. And yet none of the paintings hanging on the front of the school and the houses on the left can be identified, not even the one — the first on the right — that was mistakenly thought in the past to be a reproduction of the juvenile *veduta* of the *Campo dei Santi Giovanni e Paolo* by Canaletto himself, acquired by the Imperial ambassador and now in Dresden: it is as if Canaletto had scornfully refused to give space to other artists in his own painting.

In any case, Canaletto cannot have been a person with an easy-going character. Evidence for this is provided by a number of passages that crop up in letters written by people who had to deal with him. Owen McSwiney, for instance, wrote to the Duke of Richmond in 1727: "The fellow is very difficult and keeps on changing the price everyday; and if one wants to have a picture, then one has to be careful not to make it too obvious to him as one runs the risk of losing by it, in price as well as in quality." And in another letter written three years later to John Conduit: "He is a greedy and grasping man, and as he is famous people are happy to pay whatever he asks." Nor can his relationship with Smith have been wholly idyllic, given that on at least one occasion the Englishman complained to a correspondent about the painter's "impertinence." Count Tessin expressed himself in still harsher terms when, after a visit to Venice from Stockholm in 1736, he described Canaletto as miserly, pretentious, and even a bit of a cheat, while De Brosses, in 1739-40, placed the accent on his avidity, concluding bitterly that it was impossible to bargain with him.

Canaletto's splendid season of the thirties came to an end with numerous other masterpieces, of which it is worth mentioning at least *The Molo and the Riva degli Schiavoni: from the Bacino di S. Marco* now in the Toledo Museum of Art, datable to 1740. The painting was part of a group, subsequently dispersed, of thirteen *vedute* that were added, probably at different times during the eighteenth century, to the collection of the Princes of Liechtenstein in Vienna, and which also included the four juvenile canvases referred to above. The painting in Toledo is a wonderful example of Canaletto's mature style, with its extraordinary brilliance of color and superb clarity.

The *vedute* of *The Molo looking toward the Mint* and *The Riva degli Schiavoni: looking East* in a private collection in Rome are of almost the same quality and we prefer to date them to this period rather than to an earlier one as has been proposed in the past.

59. Canaletto
Capriccio with the Horses of the Basilica di S. Marco set on the Piazzetta
108x129.5 cm
Windsor Castle, Royal Collections

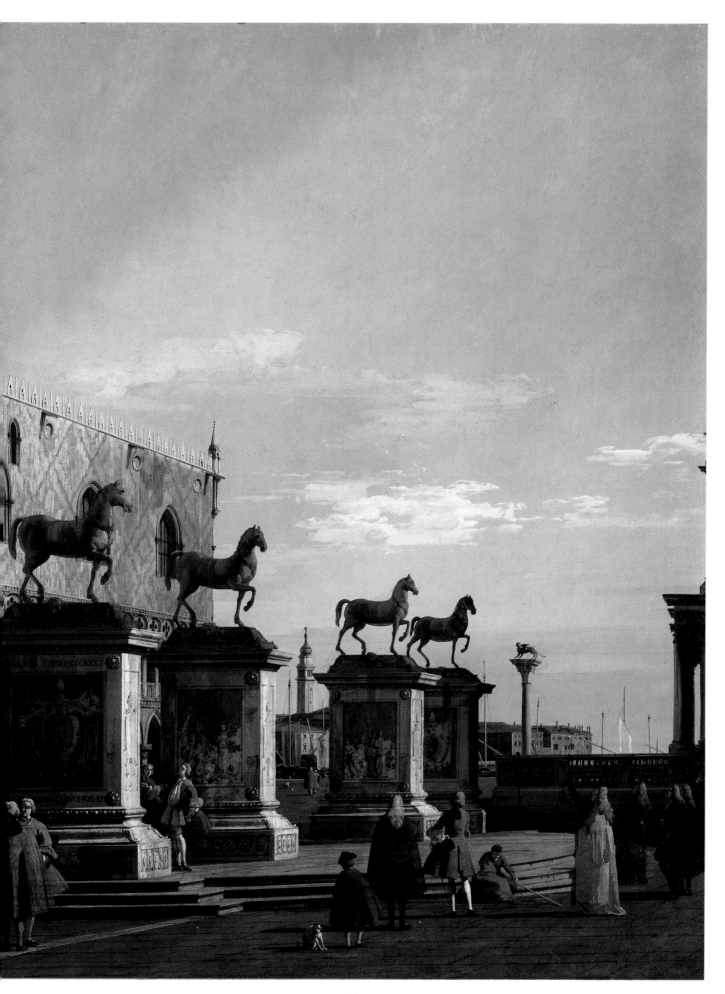

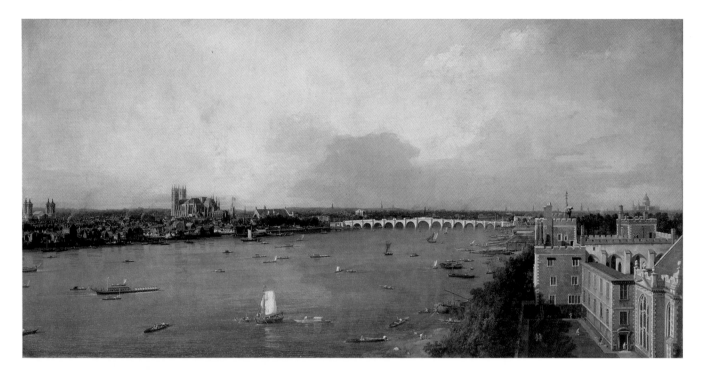

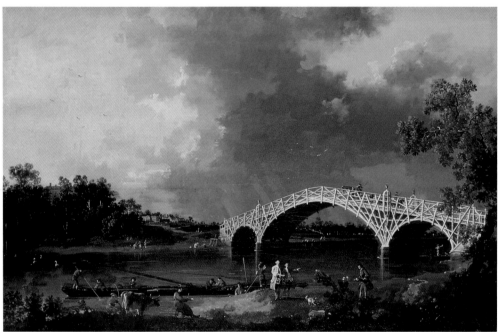

60. Canaletto
London: seen from an
Arch of Westminster
Bridge
118x238 cm
Prague, Národní
Galerie

61. Canaletto
Old Walton Bridge
46.5x75 cm
London, Dulwich
College Picture Gallery

At the start of the fifth decade Canaletto's production seems to have passed through a peculiar stage: in the years from 1741 to 1744 he made the thirty-five etchings that, collected in a volume entitled *Vedute altre prese da i luoghi altre ideate*, would be published the same year as the coveted nomination of Joseph Smith to the post of British consul in Venice and with a dedication to him "in token of esteem and respect" on the title page. In 1742 he painted a long series of Roman *vedute*, much of them now in Windsor Castle, that were certainly based on the drawings made by his nephew Bernardo Bellotto during his stay in Rome. In the years immediately following he resumed his production of *capricci*, typical of his youth. The thirteen ornamental panels (of which only eleven have survived) that he painted for Smith between 1742 and 1744 must be considered *capricci*, in which the painter broke down the reality of Venice and reassembled it to his own satisfaction: famous examples of this include the painting in which he places the team of horses set on the upper order of the facade of St Mark's on the ground in front of the church itself, and the one where he imagines, inserted neatly between the banks of the Carbon and the Vin, the Rialto Bridge as it had been designed in the late sixteenth century by Andrea Palladio but rejected at the time in favor of the one proposed by Antonio da Ponte.

This change of direction, this search for new themes and new means of expression, may have been the consequence of changing political conditions in Europe: the

50

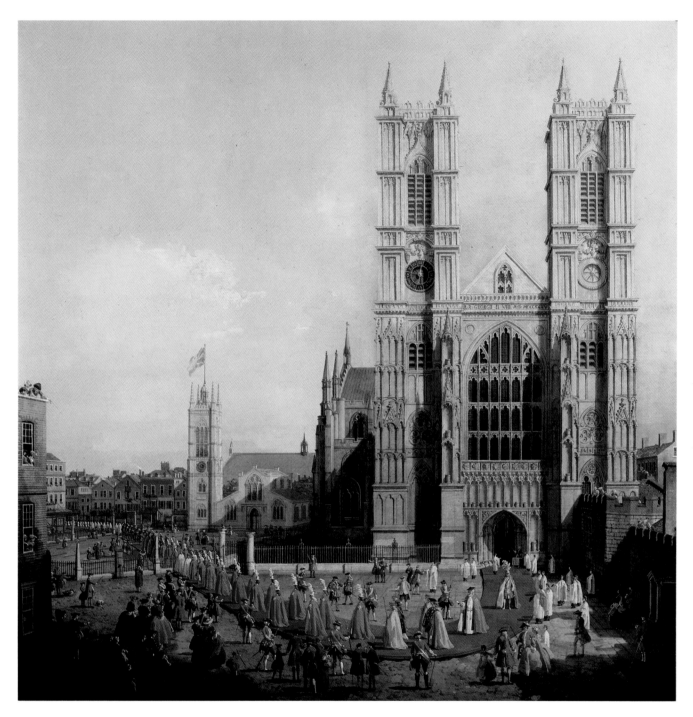

62. Canaletto
London: Westminster Abbey with a Procession of
the Knights of the Order of the Bath
99x 101.5 cm
London, Westminster Abbey

outbreak of the Austrian War of Succession had drastically reduced the flow of tourists to Venice and this had resulted in a diminution, if not the complete disappearance, of the painter's profitable commissions from abroad.

This was probably also the reason for Canaletto's decision to go to England, a direction in which he was in any case naturally led by his still close ties with Smith.

Antonio reached London in May 1746, bearing a letter of recommendation written by Smith himself and addressed to Owen McSwiney, in which the consul asked the Irishman to put the painter in touch with the Duke of Richmond. Though the latter was absent, Canaletto was fortunate enough to be introduced to Sir Hugh Smithson, the future Duke of Northumberland, who became his first client in England, as well as his protector.

Notwithstanding this exalted patronage, the Venetian painter cannot have found his stay in the country an easy one, partly owing to difficulties in his relations with English artists. In fact they sought to discredit him, by spreading the rumor that he was not the real Canaletto, but his nephew, Bernardo Bellotto, who by this time had left Venice as well. Canaletto reacted to this slur

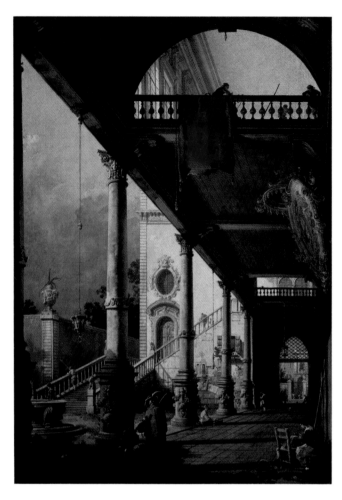

63. Canaletto
*Capriccio: a Colonnade opening onto the
Courtyard of a Palace*
131x93 cm
Venice, Gallerie dell'Accademia

64. Canaletto
Scala dei Giganti
42x29 cm
Mexico City, private collection

by placing an advertisement in the *Daily Advertiser* in 1749 and again in 1751, inviting art lovers to come and watch him painting in his studio on Silver Street (now Beak Street) near Regent Street in the heart of London.

In spite of this hostility, Canaletto received numerous commissions in London and painted about fifty large *vedute* during his stay in England, some of them of the highest quality. Works like *London: seen through an Arch of Westminster Bridge*, painted in 1747 for the Duke of Richmond, or the two *Views of the Thames* produced at the same time for Prince Lobkowitz and now in Prague, or the well-known *Old Walton Bridge* in Dulwich Picture Gallery, painted for Thomas Hollis, are hardly inferior to the luminous and lively Venetian *vedute*. Canaletto paid particular attention to portraying daily life as well and in all his English paintings the depiction of ceremonies is very precise (see for example *London: Westminster Abbey with a Procession of the Knights of the Order of the Bath* of 1749, now in Westminster Abbey), as is that of the uses and customs of the country's inhabitants.

Canaletto remained in England until 1755, interrupting his stay in 1750 to go back to Venice for eight months, so that he could invest the money he had earned in London. On his definitive return to his native city, he went back to painting pictures for foreign clients, who had started to turn up in Venice in large numbers again with the improvement in the political situation in Europe. Yet his output in the last decade of his life rarely reached the heights attained by his earlier work: in fact paintings of really high quality were few and far between. Among them, however, we have to place the two extremely refined canvases now in the National Gallery in London depicting the *Procuratie Nuove at the Cafe Florian* and *Piazza S. Marco from the Ascensione*, datable to no later than 1760, in which the painter concentrates primarily on the capricious play of light, and the series of four *vedute* painted between 1758 and 1763 for Sigismund Streit, now in Berlin. Of these, the two night pieces representing the *Night Festival at San Pietro di Castello* and the *Festival on the Eve of Sta. Marta* are particularly effective.

In 1765 Canaletto, who had only been admitted to the Academy of Painting and Sculpture two years earlier in the capacity of a painter of perspective, donated a *Capriccio: a Colonnade opening onto the Courtyard of a Palace* (now in the Galleries of the Accademia di Venezia) to this institution. The arrangement of the scene presents singular analogies with another contemporary *veduta*, this time painted from life, depicting the *Scala dei Giganti*, now in a private collection in Mexico City, which is probably one of his last pictures of Venice.

In fact Antonio died on April 18, 1768. Strangely, the inventory of his possessions reveals that he was far less well off than might have been expected, given his universally proclaimed avarice and the enormous quantity of pictures he had painted. In reality, at the time of his death, Canaletto possessed 2,150 ducats deposited with the Scuola dei Luganegheri, which would be divided between the three sisters who survived him (Antonio had never married), 300 ducats in cash, a few pieces of poor quality furniture, some jewelry of little value, twenty-eight paintings that were left in his studio, and a modest wardrobe made up for the most part of old and shabby clothes and cloaks.

A man of difficult character, Canaletto had no workshop, even though there is no doubt that he occasionally made use of assistants. A number of painters, such as Moretti, Tironi, or Fabris have been put forward in the past as his pupils, but it is more likely that they were simply imitators, and in any case of mediocre quality.

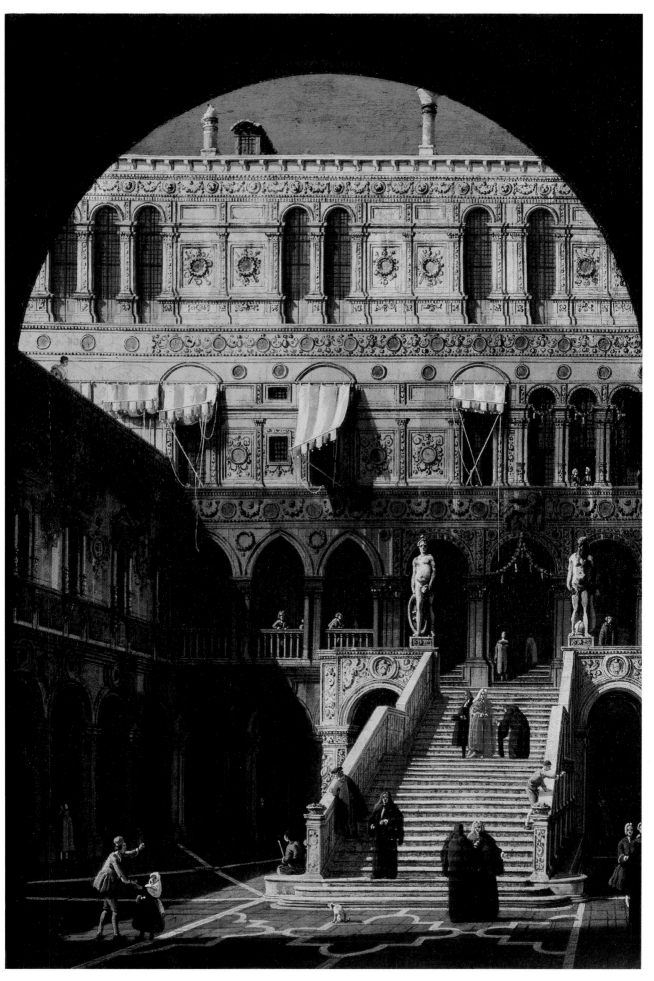

Bernardo Bellotto

The only painter who undoubtedly did work alongside Canaletto — although just for a short time — was the son of his sister Fiorenza, Bernardo Bellotto (Venice 1721 - Warsaw 1780). It can be deduced from the testimony of his contemporary Pietro Guarienti (1753) that Bernardo began to collaborate with his uncle at a very young age, around 1735. Nevertheless it is surprising to find that he was already enroled in the guild of Venetian painters in 1738, at the age of seventeen, which means that he must have already started to work independently. At least at the beginning, this would have consisted essentially in making copies of the paintings and drawings of his famous uncle. According to Guarienti, "he took to imitating him with much study and application." The same writer tells us of the various journeys made by Bernardo, to Rome and the principal cities of Northern Italy, where he executed numerous *vedute* and "painted many of those of Venice so diligently and so naturally, that it requires a very knowledgeable eye to distinguish them from those of his Uncle." This claim of Guarienti's is not without foundation, and the problem of distinguishing between the *vedute* of Bellotto and Canaletto is one that has thoroughly exercised the skills of modern critics.

According to the current state of studies, a limited number of *vedute* of Venice can be attributed with certainty to the young Bellotto, many of them previously regarded as the work of Canaletto. They include the four canvases, which originally formed a single group but are now split between the National Gallery in Ottawa and the Mills collection in Ringwood, in which that search for "objective" reality typical of Bellotto's later output, and so different from Canaletto's "virtual" reality, seems most clearly visible. Another is the *View of the Rio dei Mendicanti and the Scuola Grande di San Marco* in the Gallerie dell'Accademia in Venice, which is characterized by an intense contrast between the brightly lit parts of the scene and the extensive areas that are wrapped in deep and sharply defined shadow, and by the impasted paint, laid on in thick, parallel brush stro-

65. Bernardo Bellotto
View of the Rio dei Mendicanti and the Scuola Grande di San Marco
42x69 cm
Venice, Gallerie dell'Accademia

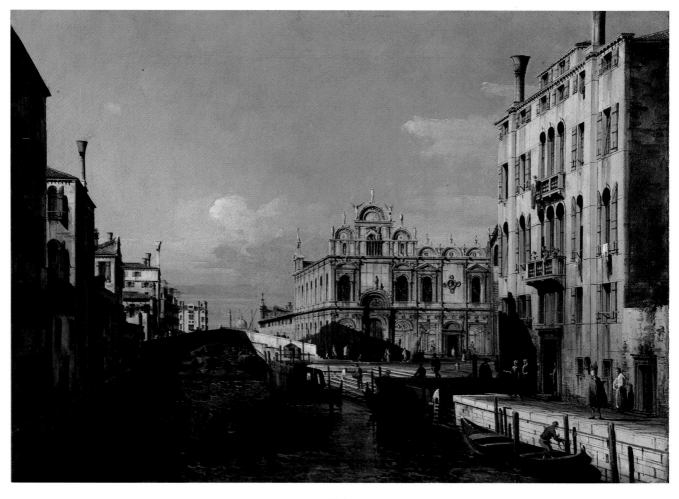

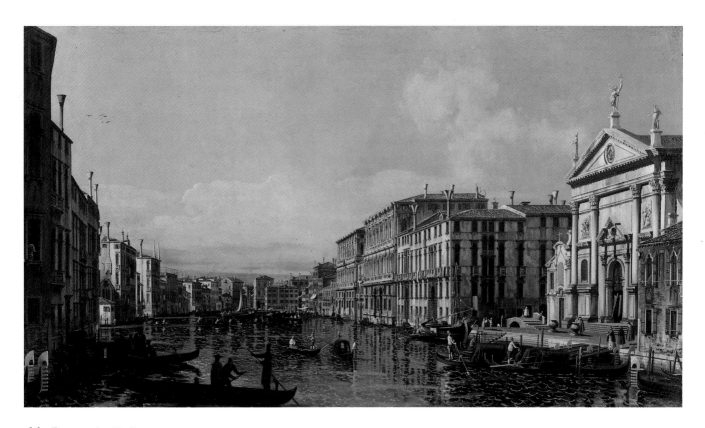

66. Bernardo Bellotto
A View of the Grand Canal at San Stae
70.5x126.5 cm
Milan, private collection

kes. Then there is the *View of the Grand Canal at San Stae* in a private collection, where cold tones of color predominate and it is easy to discern the unmistakable quality of Bellotto's lean figures, rendered with thick brush strokes and looking almost like caricatures. Lastly, there is the *View of the Campo dei Santi Giovanni e Paolo* in Springfield, based on the drawing signed and dated December 8, 1740, now in the Darmstadt Museum.

The same German Museum also has the preparatory drawing for the *View of Campo Santo Stefano* in Castle Howard, which is more or less the same view as the one painted by Canaletto for the Duke of Bedford in the thirties. A comparison between the two paintings is extremely useful in revealing the differences — subtle at this date — between Antonio and Bernardo, evident in Bellotto's use of a more marked contrast of light and shade between the sunlit areas and those in shadow, and in his typical way of painting elongated figures.

The journey to Rome, with stopovers in Florence and Lucca, mentioned by Guarienti must have taken place in 1742, during the interval between Bernardo's marriage to Maria Elizabetta Pizzoni in November 1741 and the birth of their first son, Lorenzo, in October of the following year. Confirmation is provided by topographical details in the *vedute* he painted in the papal city, which are perfectly in keeping with this date.

At the time of his departure for Rome, however, Bellotto must have already established a reputation for himself in Venice, and four of his *vedute* — identified by some as the group now divided between Ottawa and Ringwood — had been acquired by Marshal Schulenburg in November 1740. In 1744 Bernardo left Venice again, heading for Lombardy and, the following year, Turin: it was at this time that he painted the splendid *vedute* of the Gazzada and the capital of the House of Savoy. His divergence from Canaletto's style is already evident in these works, and the difference was to become a gulf in the later *vedute* of Verona, where Bellotto went in 1746. This was the year that Canaletto left Venice for London. In July of the following year Bernardo too left Italy, going to Dresden with his wife and children, a sign that he intended to be away from his native city for a long time. And in fact Bellotto was never to return to Venice, but stayed to work in the German states, in Saxony, Vienna, and Munich. In 1766 he went to Warsaw, where he died.

Michele Marieschi and Francesco Albotto

Another interesting *vedutista*, Michele Marieschi (Venice 1710-1743), was some ten years younger than Bellotto. His complex artistic personality still presents large areas of obscurity. What we do know is that Marieschi — like Canaletto before him — began his career in the field of theatrical scene painting, in the retinue of Gaspare Diziani, a figure painter from Belluno who was probably his patron, and that he married Angiola Fontana in 1737. There has been much debate over a journey that Michele made to Germany as a young man. There, according his contemporary Guarienti (1753), "the whimsicality and wealth of his ideas pleased many people, who employed him in large and small undertakings." Just what was involved in these "undertakings" is not certain: one clue is provided by the fact that Diziani had been in Germany from 1717 to 1719, where he also worked as a scene painter. So it is possible that it was the painter from Belluno who had pointed his young protege in the direction of the German world.

Marieschi's activity as a scene painter is recorded in a few engravings. One is by his own hand and represents a *Scenic View of a Large Courtyard* and was intended, as can be deduced from the inscription, as a set design. The other two, made from drawings of his that have been lost, were published to commemorate the funeral of Maria Clementina Sobiescki, Queen of Poland, held in Fano in 1735. The work of Giuseppe Camerata and Francesco Tasso, the two engravings depict the funeral decorations and *Castrum doloris* set up in the church of San Paterniano, clearly derived from the set designs of the Bibiena family. Other signs of the influence of the Bibiena can be found in Michele's paintings, especially in his numerous *capricci*, most of them organized around a single, central vanishing point on which the side scenes converge.

A large number of views of Venice are attributed to Marieschi, but there still seems to be a great deal of work to be done on the precise definition of his catalogue. In fact the recent revival of interest in the painter — who in the past, incredibly, was confused for a long time with the mediocre rococo figure painter Jacopo Marieschi — has sparked off considerable disagreement over at least two fundamental questions: on the one hand, the distinction between Michele's own works and those of his pupil and successor Francesco Albotto; on the other his disputed collaboration with other artists (the aforementioned Diziani, Francesco Fontebasso, Simonini, Antonio and Francesco Guardi, and Giambattista Tiepo-

67, 68. Michele Marieschi
View of the Basilica della Salute
124x213 cm
Paris, Louvre

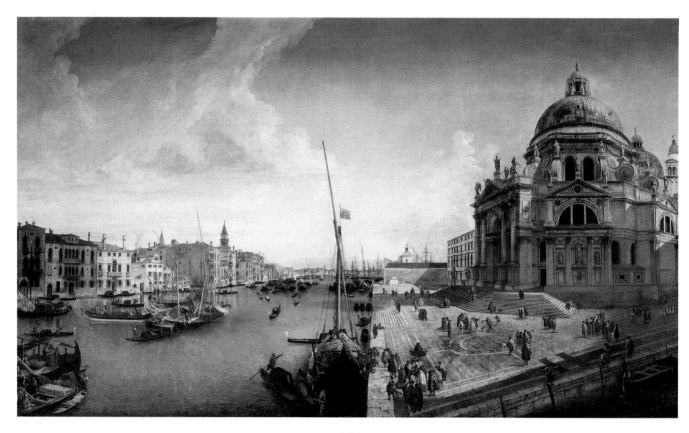

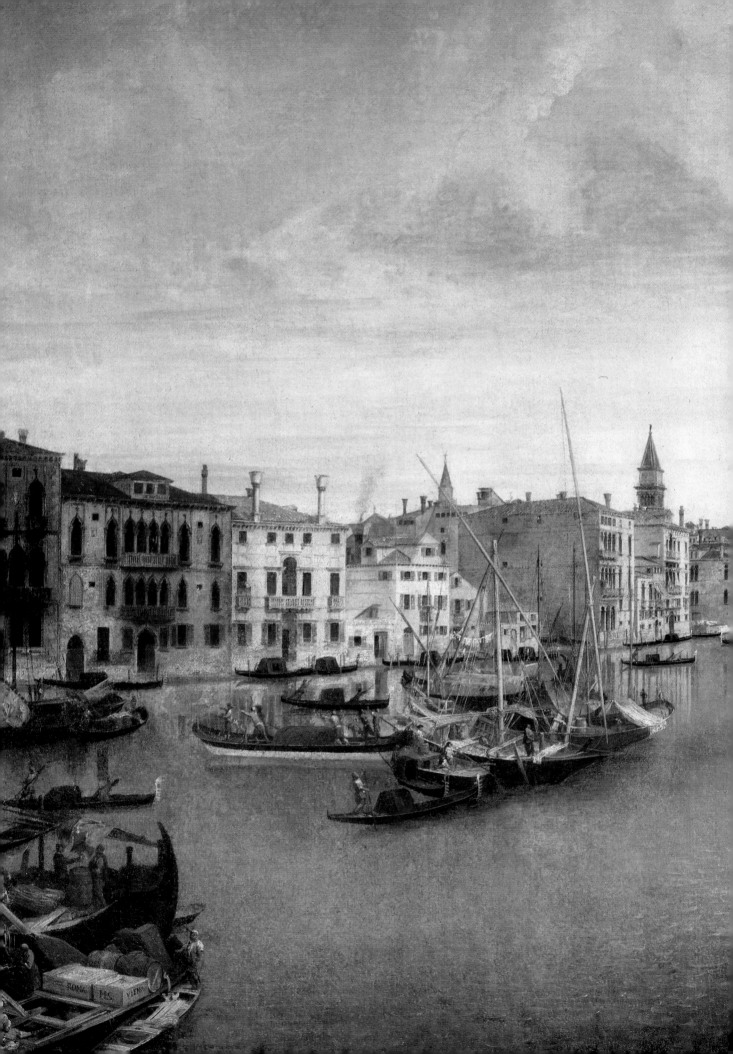

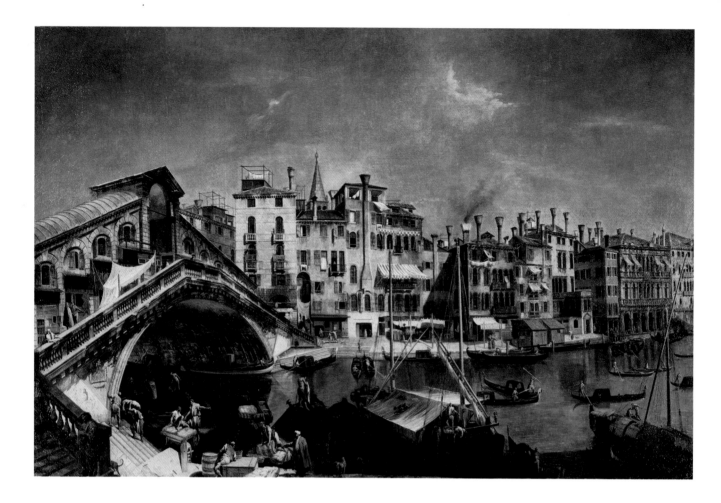

69, 70. *Michele Marieschi*
The Rialto Bridge with the Riva del Ferro
130x195.5 cm
St. Petersburg, Ermitage

lo are the names most often cited), who according to some critics were responsible for the main figures that appear in the paintings and engravings of Marieschi.

Michele's career as a painter in Venice was a short one, and can be limited to the years between 1735 and 1742: in January of the following year in fact, the painter, "burdened by illness," drew up his last will and testament and just a few days later, at the age of only thirty-two, concluded his brief life. A brief but highly industrious one, if we are to believe Guarienti's claim that "excessive application to toil and study caused his death."

As a consequence, his catalogue is fairly limited, in view of the fact that it was during this short period that he also executed the twenty-one large etchings published in 1741 under the title of *Magnificentiores Selectioresque Urbis Venetiarum Prospectus*, which constitutes one of the greatest masterpieces of Venetian eighteenth-century engraving.

There can be no doubt that Marieschi achieved considerable success as a painter in Venice: proof of this comes from the fact that as early as 1736 Marshall Schulenburg had purchased his *View of the Courtyard of the Doge's Palace* for the high price of 50 sequins. The work, which has recently surfaced on the British antiquarian market, is of remarkable quality, connoted by the scenic and unusual spaciousness bestowed on the impressive courtyard, the marked distinction be-

tween the area shrouded in deep shade and the one flooded with dazzling light, which brings out every detail of the rich architectural decoration. In 1737 the Marshal bought another *veduta* by Marieschi, depicting the *Entry of the Patriarch Antonio Correr* (now the property of the British National Trust), which shows the procession made up of richly decked gondolas in the vicinity of the Rialto Bridge.

This view, in which the predilection for the expansion of spaces typical of Marieschi's training as a scene painter is still apparent, can profitably be compared with other famous paintings of his: for instance the *View of the Basilica of La Salute* in the Louvre or that of the *Rialto Bridge with the Riva del Ferro* in the Hermitage in St Petersburg. For a long time both of these spectacular works were attributed to Canaletto and it is only recent scholarship that has reassigned them to Marieschi's catalogue, of which they are perhaps the most refined examples. Characteristic of both is the "angled" point of view, which expands the breadth of the *veduta* enormously; typical, too, is the way that the works of architecture are painted with intersecting and

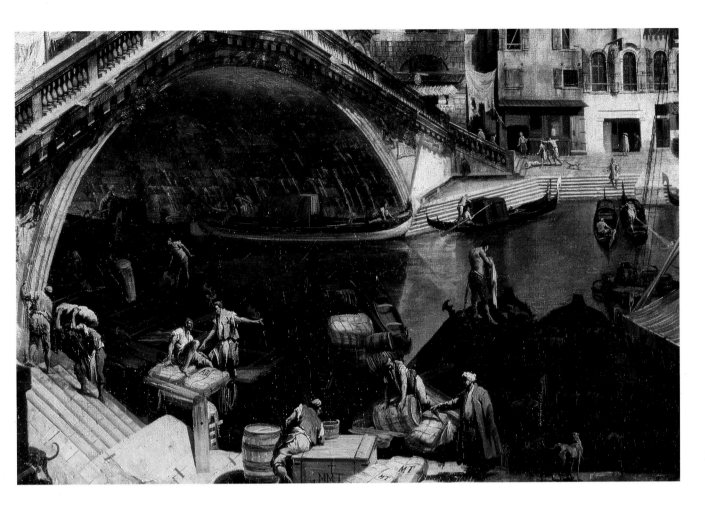

overlaid brush strokes, using thick paint laid on in lumps.

We do not know whom these pictures were painted for, but the names of several of Marieschi's foreign clients are known, a fact that demonstrated how Marieschi's fame had spread beyond the confines of the Republic of Venice. For example, three of his *vedute* were acquired in Venice in 1743 by the father of the first Earl of Malmesbury, James Harris. Another group of four views found its way to Castle Howard, the residence of those Earls of Carlisle whom we have already met in the guise of collectors of the works of Canaletto and Bellotto. The two *vedute* now in Berlin, on the other hand, come from the collections in the castle of Sans-Souci, having been purchased in Venice through the mediation of Francesco Algarotti.

It is not easy to establish a precise chronology for Marieschi's works, painted as they were over the space of a few years and therefore without any significant modification in his style. However in a large number of his masterpieces, such as the *View of the Rio di Cannaregio* in Buccleuch or the matching pictures that used to be in the Hallsborough collection in London depicting the *Grand Canal at San Geremia* and the *Grand Canal with the Fish Market*, the small figures in the foreground suggest the sparkling brushwork of Antonio Guardi.

At the time of Marieschi's death, at the beginning of 1743, he had a young apprentice, Francesco Albotto.

Pierre Mariette mentions him briefly in his *Abécédaire*, written before 1744, stating that he "paints views of Venice and landscapes adorned with works of architecture that are not badly handled" and that he called himself the "second Marieschi," having even married his widow. Since that time the artist faded out of the limelight, up until the time when, in 1972, a *View of the Doge's Palace from the Basin* turned up on the antiquarian market in New York, with the words "Francesco Albotto F. in Cale di Ca Loredan a San Luca" written on the back of the canvas, presumably in his own hand. Thorough investigation of the archives has recently brought to light further biographical information on this painter, who seems to have married Angiola Fontana, Marieschi's widow, on October 29, 1744, and to have been enroled in the guild of Venetian painters from 1750 to 1756. Albotto too died at the very early age of thirty-five, on January 13, 1757. This allows us to deduce that he was born in 1721 and was therefore about ten years younger than his master.

While considerable progress has been made in uncovering the details of Albotto's life, the same cannot be said as far as the tracing of works that were undoubtedly painted by him is concerned: in fact the only established painting of his remains the view of the Doge's Palace referred to above, and even this is only known to scholars through a black-and-white photograph, as the painting is in an inaccessible private collection.

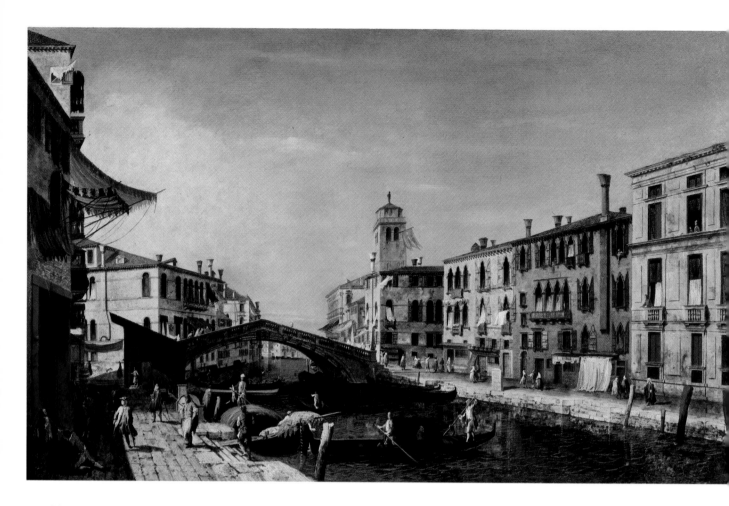

However many other paintings have been attributed to him, essentially on the basis of their "inferior quality" with respect to those by Marieschi. In other words, one starts out from the presupposition that any painting "in the manner of Marieschi" but that does not attain the level reached by Marieschi, or that has topographical features indicating a date after 1742, must be the work of Albotto. This approach is not without its risks, given that it relies, for this painter as well, on the insidious method of attribution "by exclusion" that has yielded misleading results in other cases. Paradoxically, it is the same operation to which Marieschi's catalogue was subjected, around the middle of this century, with the inclusion of all the *vedute* of Venice of a certain quality that could not be attributed to Canaletto or Guardi.

Naturally, this does not mean that it is necessary to reject the labors of those who have been trying to build up a critical catalogue of Albotto's works exclusively on the basis of logical deductions that, although frequently persuasive, are, by their very nature as deductions, not absolute certainties. In fact it has to be remembered that there were a large number of painters active in Venice in the middle of the eighteenth century and that many of them were *vedutisti*. For example, what do we know of the paintings of Bernardo Zilotti, whose only surviving works are engravings even though the sources tell us he was a *veduta* and landscape painter? And what about Giovan Battista Grassi? And Tironi? Who can tell

71. Michele Marieschi
View of the Rio di Cannaregio
52x85 cm
Bowhill, Selkirk, Buccleuch Collection

72, 73. Michele Marieschi
The Grand Canal at San Geremia
54x82 cm
London, private collection

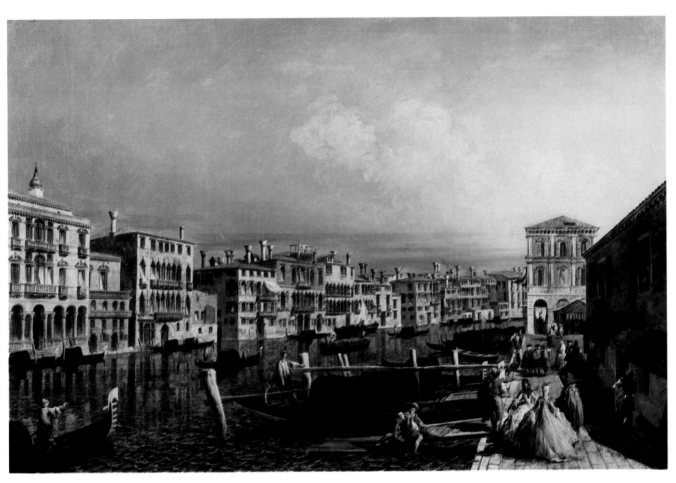

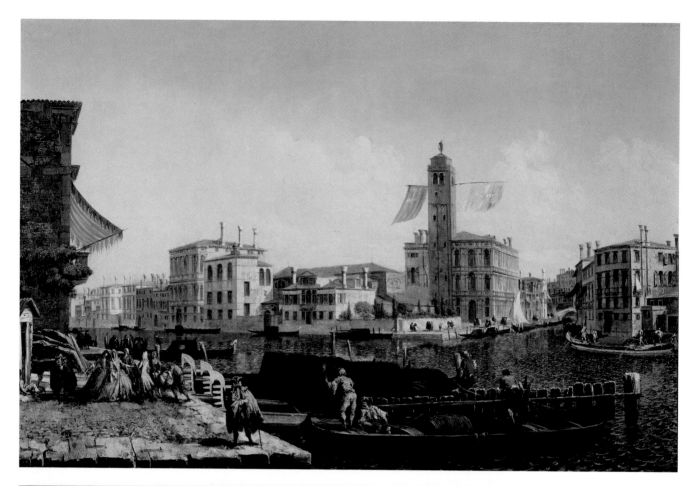

*74-76 Michele Marieschi
The Grand Canal with
the Fish Market
55x82 cm
London, private
collection*

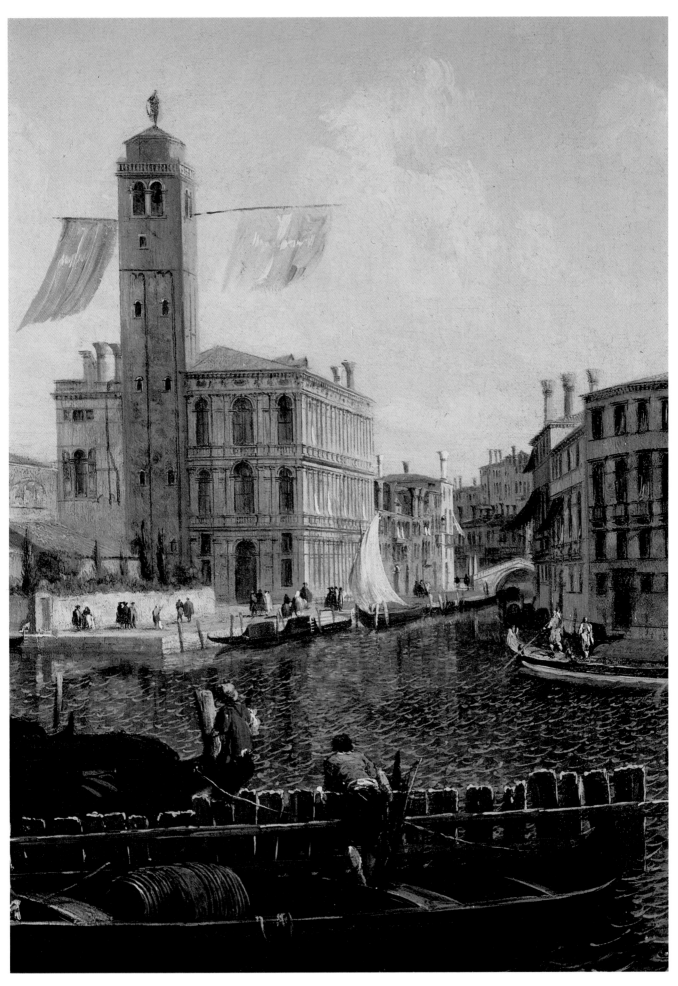

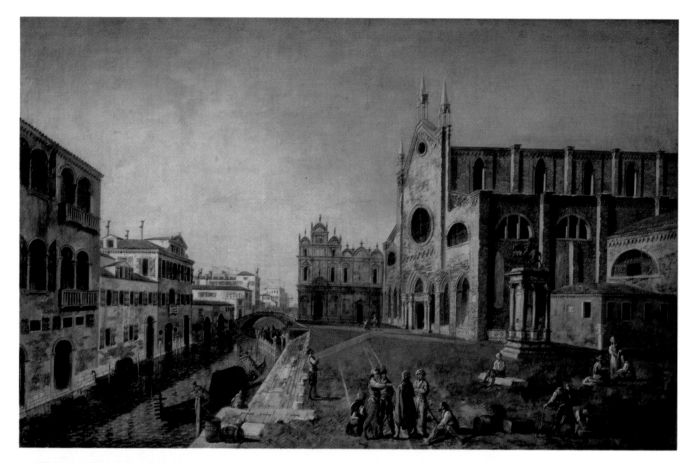

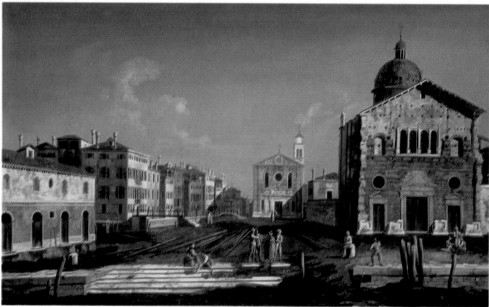

77. Francesco Albotto
View of Campo Santi
Giovanni e Paolo
61x97 cm
Naples, Galleria
Nazionale di
Capodimonte

78. Francesco Albotto
San Giuseppe di
Castello
59.5x97 cm
Venice, private
collection

whether there is not another "second Marieschi" concealed among these and many other names of "painters without paintings?"

Emblematic of this is the case of the recent discovery of a painter to whom the critics have not yet been able to give a name. Another artist with a style similar to Marieschi's, he was the author of a group of thirteen views of Venice now in the Langmatt Foundation in Baden that seem to date, on the basis of the topographic features they contain, from 1743-4.

Nonetheless, it is still credible that Albotto painted the twelve *vedute* in the Capodimonte in Naples that had previously been attributed to Marieschi, but whose topographic features mean that they must date from a period later than 1742. Just as the process of deduction that has led to the assigning to Albotto, at a date subsequent to 1745, of the two fine *vedute* depicting the *Rio di Cannaregio with the Ponte dei Tre Archi* and the *Churches of San Nicolò and San Giuseppe di Castello* in a private collection in Venice, the second of which clearly derives from a model by Canaletto and not Marieschi, appears to be a logical one.

Francesco Guardi

The last great Venetian *veduta* painter, Francesco Guardi (Venice 1712-93) did not start painting views until the fifties. Before then, he worked in the field of figure painting. While it is not impossible that as a young man he collaborated with his elder brother Antonio, also a figure painter and the last great exponent of the Venetian rococo, who was certainly his first master at the end of the twenties, it appears that he soon broke away from his tutelage. He may already have done so by 1729, when Antonio passed on his job as painter to the Giovanelli family to Francesco in order to enter the service of Marshal Schulenburg. The Giovanelli owned many properties in Lombardy, Trentino, and Austria: the painters they employed were used for the most part to decorate the family's palaces, villas, and churches located in these areas. It is not unlikely, therefore that the young Francesco was sent to Austria by his patrons: this would explain the presence, in his juvenile paintings, of features that are more reminiscent of the works of artists like Maulbertsch or Unterperger than the airy *rocaille* lightness of Antonio.

On his return to Venice, probably after he had slackened his ties with the Giovanelli, Francesco must have decided to try out various new directions: this could be the reason why works like his various versions of the theme of the *Meeting* or *Place of Assembly* at first show the influence of Pietro Longhi, followed by the choice to devote himself to the *veduta* and landscape.

There has been much debate over just when he took this decision: the most recent criticism leans toward the hypothesis that his first venture into the genre of the *veduta* was made around the middle of the sixth decade, that is at a time when the influx of tourists to Venice began to revive after the end of the War of Austrian Succession and when Canaletto, who remained in London until 1755, was absent.

In an entry in his *Notatori* dated April 25, 1764, the nobleman Pietro Gradenigo wrote that "Francesco Guardi... a good Disciple of the renowned Canaletto, having had great success in using the *Camera Optica* to paint two canvases of a certain size, ordered by an English Visitor, with views of St Mark's Square looking toward the Church, and the Clock, and of the Rialto Bridge, to the left [of the] Fabbriche in the direction of Canareggio, put them on show today on the sides of the Procuratie Nove, and thereby procured universal approval." This brief, and well known, note by Gradenigo is the only mention of Francesco's activity to have been made by a contemporary writer and is fundamental to an understanding of the step that Guardi had taken in dedicating himself to the *veduta*.

79. Francesco Guardi
Nighttime Procession in Piazza S. Marco
48x85 cm
Oxford, Ashmolean Museum

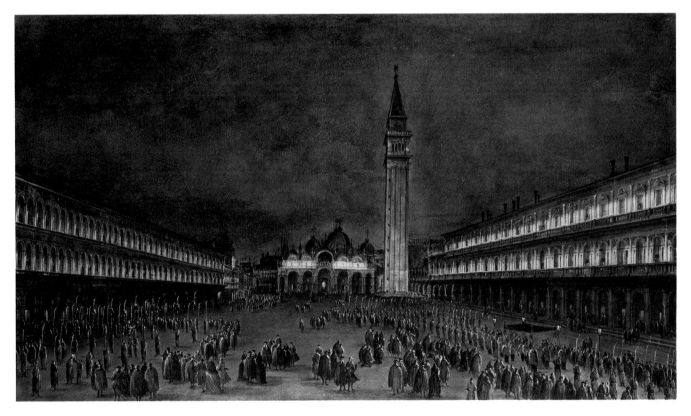

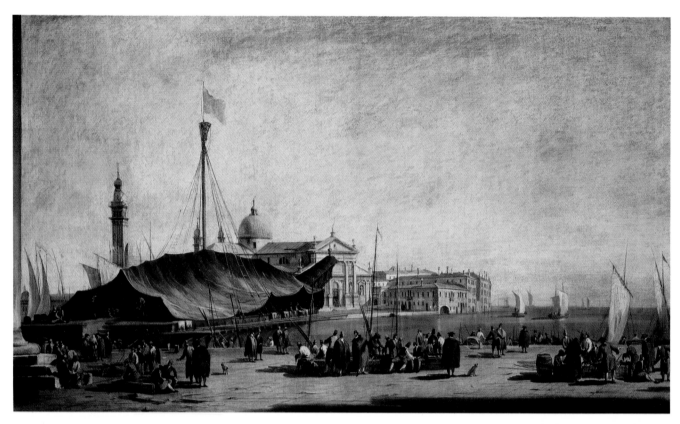

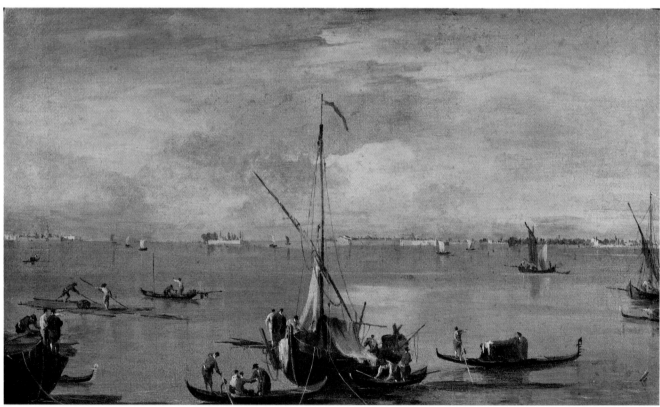

80. *Francesco Guardi*
The Piazzetta: looking toward San Giorgio Maggiore
49x83.5 cm
Treviso, Museo Civico

81. *Francesco Guardi*
The Lagoon with Boats, Gondolas, and Rafts
33x54 cm
Paris, Bentineck Collection

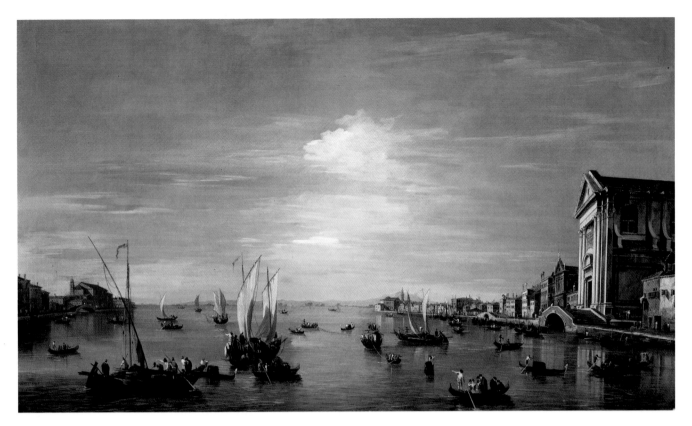

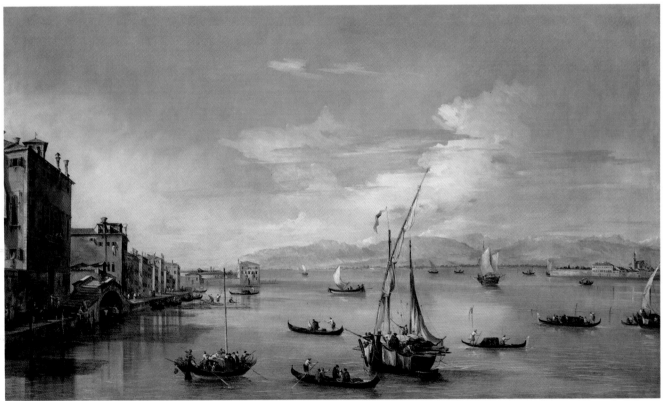

82. *Francesco Guardi*
The Giudecca Canal with the Zattere
72x120 cm
Edinburgh, formerly Buccleuch Collection

83. *Francesco Guardi*
The Lagoon: from the Fondamenta Nuove
72x120 cm
Edinburgh, formerly Buccleuch Collection

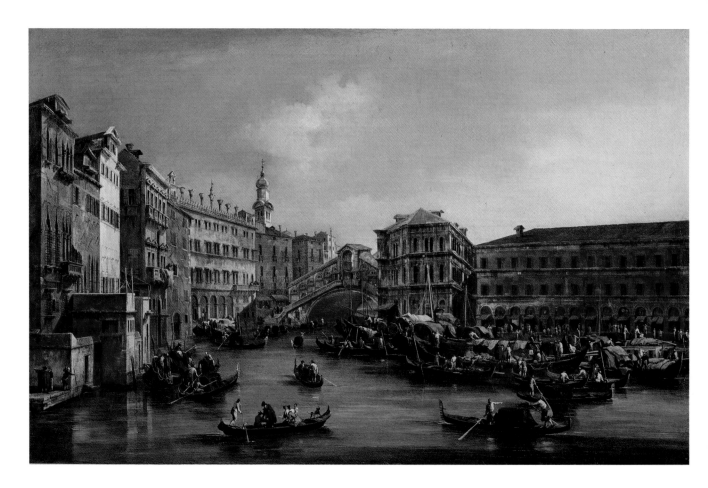

84. Francesco Guardi
The Rialto Bridge with the Palazzo dei Camerlenghi
60x91 cm
Edinburgh, formerly Buccleuch Collection

The fact that Gradenigo describes him as a "good Disciple" of Canaletto probably ought not to be taken in a literal sense, but as signifying that at the beginning of his career as a *vedutista* Francesco took his inspiration mainly from the work of the most celebrated artist in this particular field. In fact the views of Venice that are considered to be the earliest painted by Francesco, such as the one of *San Giorgio Maggiore* in the Museo Civico of Treviso, the signed, wide-angle *St Mark's Square* in the Stockholm Museum, or the *Nighttime Procession in Piazza S. Marco* in the Ashmolean Museum in Oxford (which records the celebrations of the election of the Venetian Carlo Rezzonico to the papal throne in 1758), reveal, in their adoption of a broadened perspective, precise description of the architecture, and even the typology of the little figures, the attention that the painter paid to the models of Canaletto, confirming the reliability of the information supplied by Gradenigo. In this period he also painted numerous *vedute* of the lagoon, in a manner that is strongly reminiscent, owing to the unusual breadth of the panorama, of the celebrated drawings by Canaletto in Windsor Castle dating from the forties and representing views of the lagoon from the Motta di Sant'Antonio. For example, the one in the Bentineck collection in Paris where the real protagonist is the silent expanse of water, traversed by a few cargo boats and delimited in the background by the distant view of low buildings; or the two *vedute* formerly in Buccleuch showing the *Giudecca Canal with the*

Zattere, dominated by the great marble bulk of the eighteenth-century church of the Gesuati, and the *Lagoon from the Fondamenta Nuove*, with the bluish vision of the foothills of the Alps in the background.

Francesco's Canalettian phase cannot have lasted long: in the *vedute* from the early part of the sixties, in fact, the signs of a change in direction are already apparent, evident above all in the way that the painter paid less attention to the description of architecture and in his use of an absolutely personal coloration, tending toward warm tones, while the small figures grew more and more generic, almost standardized in the typical way he outlined their "main points." He produced numerous masterpieces at this time, such as the series of six *vedute* in Buccleuch, in one of which — the view of the *Rialto Bridge with the Palazzo dei Camerlenghi* — the campanile of San Bartolomeo appears in the form that was given to it after 1754. Others are *The Rialto Bridge* in the Gulbenkian, the *vedute* now in Munich's Alte Pinakothek, the large canvases at Waddesdon Manor, and the *Campo Santi Giovanni e Paolo* in the Louvre, based on the exceptional preparatory drawing in the Budapest Museum.

85, 86. Francesco Guardi
Campo Santi Giovanni e Paolo
72x120 cm
Paris, Louvre

The two *vedute* in the Pinacoteca di Brera, depicting the *Grand Canal: looking toward the Rialto Bridge* and the *Grand Canal at the Fabbriche Nuove*, where the description of the buildings has become even more succinct, date from shortly afterward. During this period he also painted numerous views of St Mark's Square, outstanding examples of which are to be found in the National Gallery in London and the Accademia Carrara in Bergamo. They are characterized by a sharp division between the areas in shadow and the ones illuminated by a warm light, and by the low point of view, almost at the level of the square itself, which forces the painter to set figures in the foreground that are very large in proportion to the buildings.

This last characteristic had already vanished from the works produced at the beginning of the following decade, a time when Francesco painted numerous *capricci*, as well as *vedute* like the one depicting the *Bacino di S. Marco and the Island of San Giorgio* in the Gallerie dell'Accademia in Venice, which was certainly executed prior to 1774, the year when the campanile he shows as standing to the left of the church of San Giorgio collapsed. It was in the seventies that Guardi painted

another important group of works, the twelve scenes representing the celebrations for the election of Doge Alvise IV Mocenigo and based on engravings that Giambattista Brustolon had made from drawings by Canaletto and published in 1766. It seems likely that these pictures — now in the Louvre — had been painted for Doge Alvise Mocenigo himself, in office from 1763 to 1778, and were thus the first of a series of three official commissions received by Guardi in the latter part of his career. In any case, the dating of this series to the seventies is confirmed by the clothes worn by the figures, which are not slavish reproductions of those in Brustolon's engravings, but have been updated to match the fashion of the time.

There are stylistic resemblances between the canvases in the Louvre and some — the finest — of the numerous *vedute* by Guardi in the Gulbenkian Foundation in Lisbon: for instance, the ones representing *Piazza S. Marco* with the decorations designed by Maccaruzzi and set up for the Ascension Day Fair in 1777, and that of the *Grand Canal at Ca' Foscari* during a regatta.

Francesco received the other two public commissions in 1782, when he was asked to paint a series of pictures commemorating the visit to Venice of Paul Petrovitz — the future Tsar Paul I — and his wife Maria Feodorowna, whose identities were concealed under the pseudonym of the "Conti del Nord," and a second series celebrating the visit of Pope Pius VI.

The canvases that make up these two groups — a number of replicas exist of the second, perhaps made for private clients — are now dispersed among different collections: curiously, perhaps because the painter was unused to the requirements of documentation, some of them appear to be of poorer quality than others. But they do include several of Guardi's greatest masterpieces, such as *Pius VI giving his Blessing in Campo Santi Giovanni e Paolo* in the Ashmolean Museum in Oxford, which depicts the moment when the pope, standing on a temporary platform erected in front of the Scuola di San Marco, addresses the large crowd filling the square (in anticipation of the great influx of people the Rio dei Mendicanti had been covered with planks), depicted from behind in accordance with a custom that was to become recurrent in Francesco's late works (such as the *Ascent of Count Zambeccari's Montgolfier* in Berlin from 1784 or the two versions of the *Fire in the Oil Deposits of San Marcuola*, dating from 1789, in Munich and the Galleries of the Accademia di Venezia). Another masterpiece is the *Concert of Ladies in Honor of the Conti del Nord in the Sala dei Filarmonici*, now in Munich, where Francesco reaches new heights of poetry in the vibrant light that pervades the painting.

The *Meeting of Pius VI with the Doge on the Island of San Giorgio in Alga*, in a private collection in Milan, is also of the highest quality and appears to anticipate the most famous works from the last years of Francesco's life, the *Outward Voyage of the Bucintoro to San Nicolò del Lido* and the *Return of the Bucintoro*, formerly in the Crespi collection, dating from the end of the eighties. Here the painter seems to go back, in the layout of the scenes, to the pictures of the lagoon he had painted at the end of the sixth decade or the start of the following one, at the beginning of his career as a *vedutista*. The buildings that border panoramas of "impossible" breadth are barely outlined, forming no more than a thin dividing line between the blue of the sky dotted with a few white clouds and the pale green of the water, furrowed by the countless gondolas accompanying the doge's ship. The whole is set amidst a shifting succession of small figures and boats, steeped in a light that literally eats away the edges of the forms.

Francesco attains similar heights of poetry in several more of his last works, such as the small *Rio dei Mendicanti* in the Accademia Carrara in Bergamo, where the architecture (see for example the detail of the sculpture on top of the church's tympanum, depicted with an "open" brush stroke, with no outlines) is depicted in a pictorial shorthand of exceptional charm.

And if it is true that these works, with the decomposition of their forms, were a sad omen of approaching death — Francesco was to die in the January of 1793 at the age of over eighty — then the disquieting *Gondola* in the Poldi Pezzoli, slipping alone through the silent lagoon close to the Fondamente Nuove, in front of the islands of San Cristoforo and San Michele, can be seen as the supreme symbol of a life drawing to its close. A difficult, almost poverty-stricken life, as can be deduced not only from the documents in the archives but also from what P. Edwards wrote to Antonio Canova on June 23, 1804: "You know however that this painter worked for his daily living, that he bought reject and very poorly primed canvases; and that to get by he used very greasy colors, and very often painted straight off. Anyone who bought his pictures had to resign himself to losing them within a short time, and I would not like to guarantee their lasting another ten years."

"He worked for his daily living": this was the destiny that Francesco left as his sole legacy to his son Giaco-

87. Francesco Guardi
The Grand Canal: looking toward the Rialto Bridge
56x75 cm
Milan, Pinacoteca di Brera

88. Francesco Guardi
The Grand Canal at the Fabbriche Nuove
56x75 cm
Milan, Pinacoteca di Brera

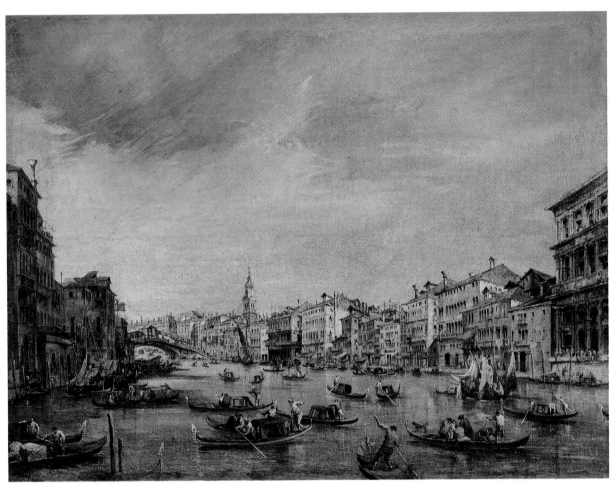

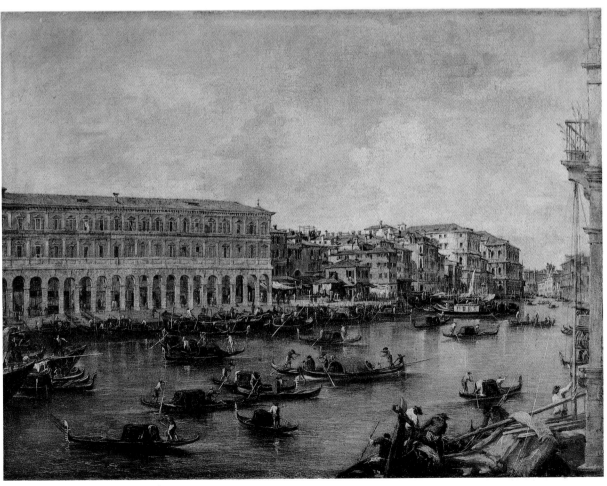

71

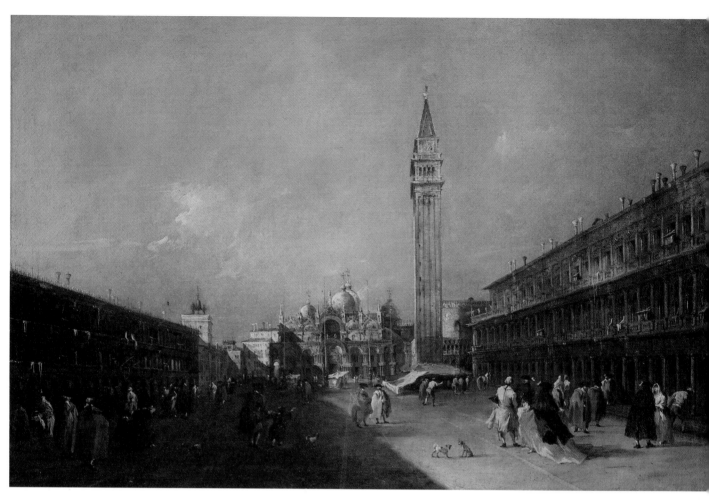

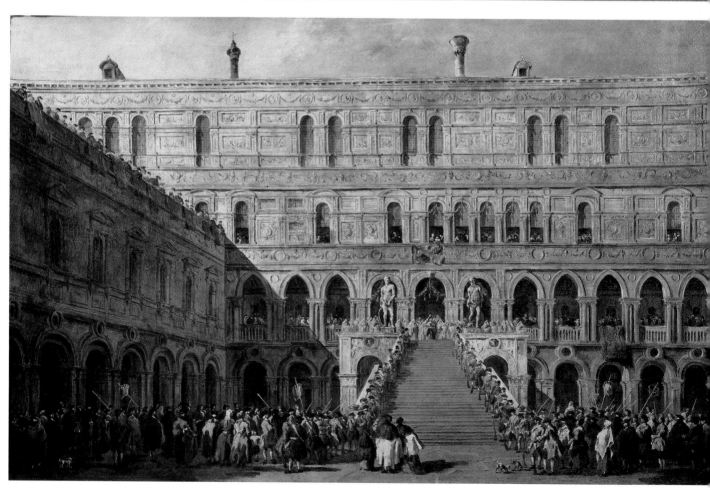

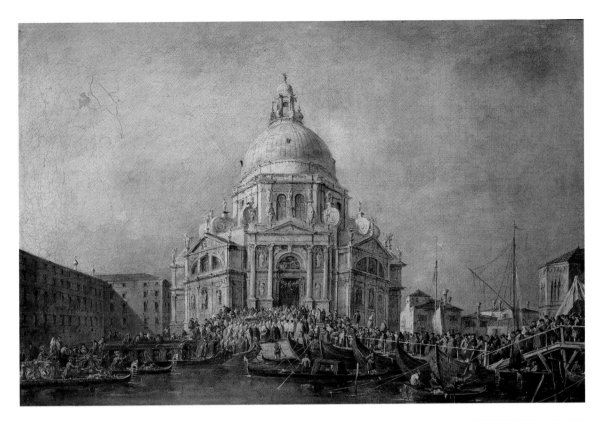

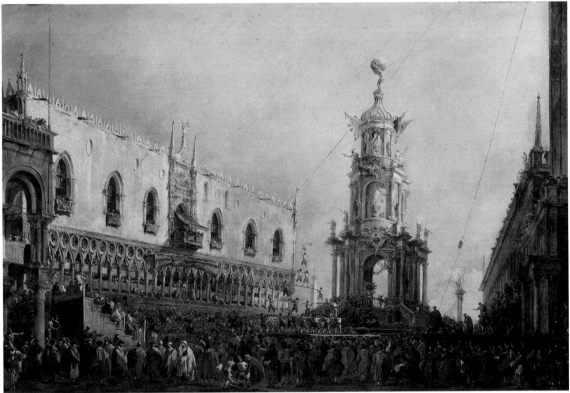

89. *Francesco Guardi*
Piazza S. Marco
62x96 cm
Bergamo, Accademia Carrara

90. *Francesco Guardi*
The Coronation of the Doge
66x101 cm
Paris, Louvre

91. *Francesco Guardi*
The Doge at the Basilica of La Salute
68x100 cm
Paris, Louvre

92. *Francesco Guardi*
Carnival Thursday on the Piazzetta
67x100 cm
Paris, Louvre

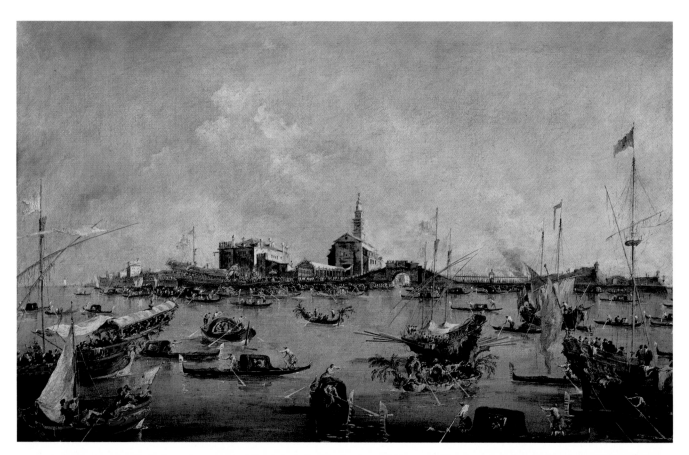

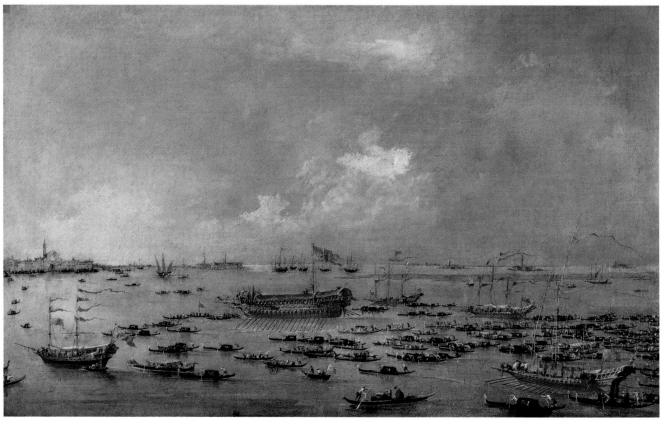

93. *Francesco Guardi*
The Bucintoro at San Nicolò del Lido
68x100 cm
Paris, Louvre

94. *Francesco Guardi*
The Outward Voyage of the Bucintoro to San
Nicolò del Lido
50x80 cm
Milan, private collection

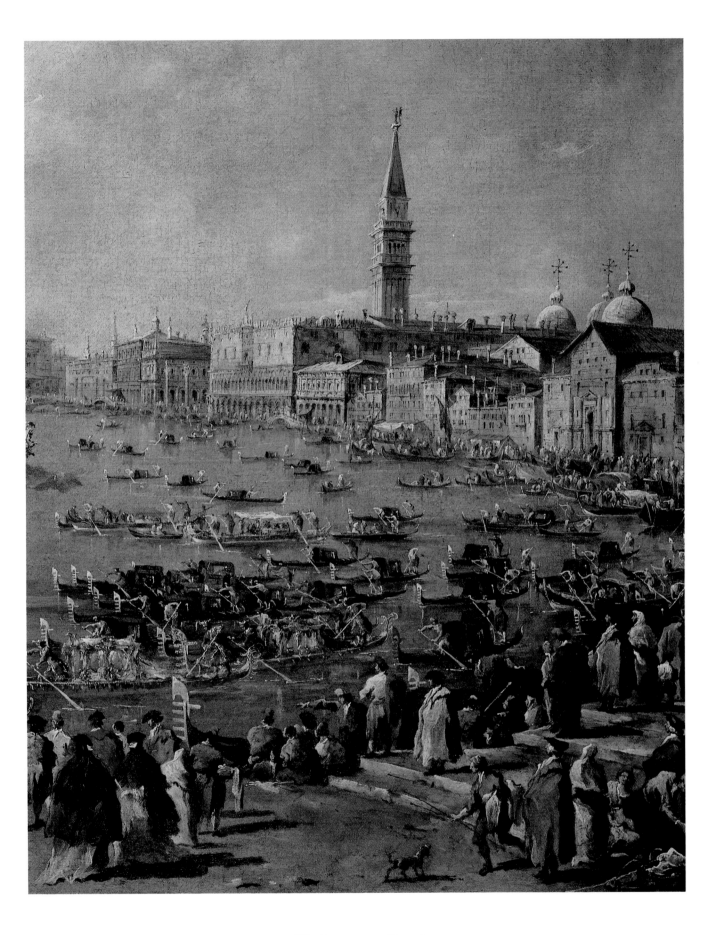

95. Francesco Guardi
The Doge on the Bucintoro near the Riva di Sant'Elena, detail
66x100 cm
Paris, Louvre

75

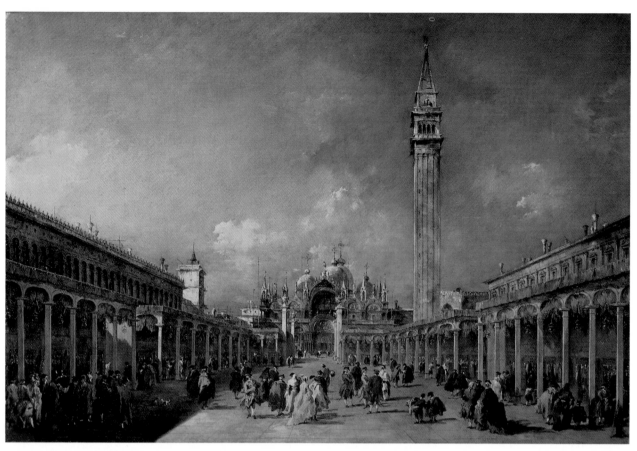

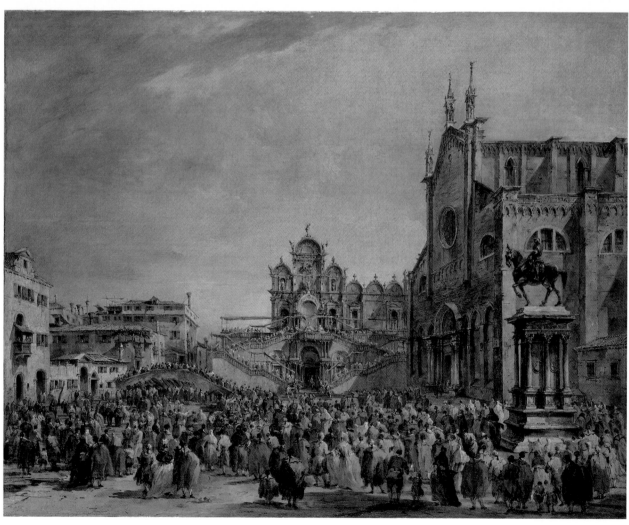

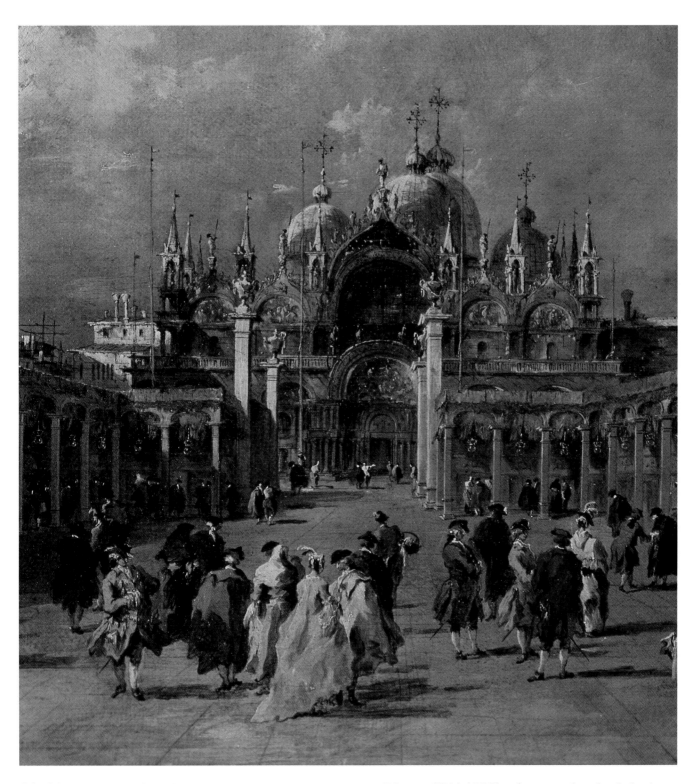

96, 98. Francesco Guardi
Piazza S. Marco
61x91 cm
Lisbon, Gulbenkian Foundation

97. Francesco Guardi
Pius VI giving his Blessing in Campo Santi
Giovanni e Paolo
63.5x78.5 cm
Oxford, Ashmolean Museum

mo (Venice 1764-1835), who carried on his father's activity, but without either his instinctive poetic inspiration or his inimitable skill as a painter. And his sorry works — which can fairly be described as postcards of no artistic value — mark the inglorious end of an exceptional age, that of eighteenth-century Venetian *vedutismo*.

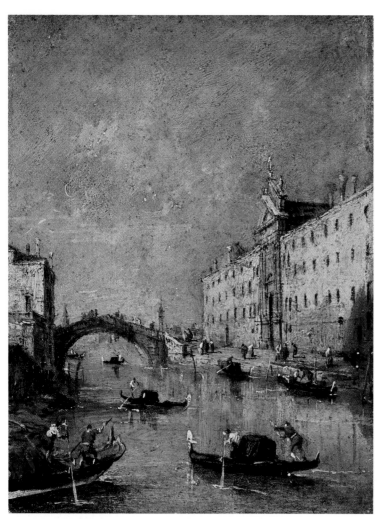

99. Francesco Guardi
Rio dei Mendicanti
19.5x15 cm
Bergamo, Accademia Carrara

100. Francesco Guardi
Gondola on the Lagoon
25x38 cm
Milan, Museo Poldi Pezzoli

Index of Illustrations

Francesco Albotto
San Giuseppe di Castello (Venice, private coll.), 78
View of Campo Santi Giovanni e Paolo (Naples, Capodimonte), 77

Bernardo Bellotto
View of the Grand Canal at San Stae (Milan, private coll.), 66
View of the Rio dei Mendicanti and the Scuola Grande di San Marco (Venice, Accademia), 65

Canaletto
The Arrival of the French Ambassador in the Doge's Palace (St. Petersburg, Ermitage), 36
Campo Santa Maria Formosa (Woburn Abbey), 43
Campo San Rocco (Woburn Abbey), 45
Grand Canal: looking Northeast from Palazzo Balbi to the Rialto Bridge (Venice, Ca' Rezzonico), 26
Capriccio with Horses (Windsor Castle), 59
Capriccio: a Colonnade opening onto the Courtyard of a Palace (Venice, Accademia), 63
The Doge visiting the Church and Scuola di S.Rocco (London, National Gallery), 53, 54
The Fonteghetto della Farina (Venice, private coll.), 40, 41
The Bucintoro Returning to the Molo on Ascension Day (Milan, Crespi Collection), 34
The Bucintoro Returning to the Molo on Ascension Day (Moscow, Pushkin Museum), 37
Grand Canal: from Palazzo Balbi (Florence, Uffizi), 57
The Grand Canal between Palazzo Bembo and Palazzo Vendramin Calergi (Woburn Abbey), 42
Grand Canal: looking toward the Church of La Salute from the Campo S.Vio (Windsor Castle), 32
The Stonemason's Yard (London, National Gallery), 38, 39
The Molo with the Library (Rome, private collection), 56
The Rialto Bridge: from the South (Rome, Galleria Nazionale), 52
Old Walton Bridge (London, Dulwich Gallery), 61
London: seen from an Arch of Westminster Bridge (Prague, Národni Galerie), 60
The Piazzetta (Windsor Castle), 30
Scala dei Giganti (Mexico City, private coll.), 64
Piazza S. Marco (Madrid, Thyssen Bornemisza), 29
Piazza S. Marco with the Basilica (Cambridge, Fogg Art Museum), 31
Piazza S. Marco: looking toward San Geminiano (Rome, Galleria Nazionale), 51
Westminster Abbey with a Procession of the Knights of the Order of the Bath (London), 62
The Reception of the Ambassador in the Doge's Palace (Milan, Crespi Collection), 33, 35
Rio dei Mendicanti (Venice, Ca' Rezzonico), 27, 28
The Bacino di S. Marco (Boston, Museum of Fine Arts), 46
Grand Canal: looking East from the Campo S.Vio (Madrid, Thyssen Bornemisza), 24, 25
The Molo and the Riva degli Schiavoni: from the Bacino di S. Marco (Toledo, Ohio, Museum of Art), 55
View of the Doge's Palace (Florence, Uffizi), 58
View of the Entrance to the Arsenal (Woburn Abbey), 44
View of Campo Santi Apostoli (Milan, private coll.), 47, 48
View of San Giuseppe di Castello (Milan, private coll.), 49, 50

Luca Carlevarijs
View of the Wharf from the Bacino di S. Marco (Montecarlo, private coll.), 17
The Wharf: looking toward the Doge's Palace (Potsdam), 14
The Piazzetta and the Library (Oxford, Ashmolean), 18

The Sea Customs House with San Giorgio Maggiore (Venice, private coll.), 11, 12
The Arrival of the Venetian Ambassadors in London (Munich Bayerische Staatsgemäldesammlungen), 16
Seascape (private coll.), 8
Piazza S. Marco with Jugglers (Potsdam), 15

Francesco Guardi
Campo Santi Giovanni e Paolo (Parigi, Louvre), 85, 86
The Bucintoro at San Nicolò del Lido (Paris, Louvre), 93
The Grand Canal at the Fabbriche Nuove (Milan, Brera), 88
The Grand Canal: looking toward the Rialto Bridge (Milan, Brera), 87
The Giudecca Canal with the Zattere (Edinburgh, formerly Buccleuch), 82
The Doge at the Basilica of La Salute (Paris, Louvre), 91
The Doge on the Bucintoro near the Riva di Sant'Elena (Paris, Louvre), 95
Carnival Thursday on the Piazzetta (Paris, Louvre), 92
The Rialto Bridge with Palazzo dei Camarlenghi (Edinburgh, formerly Buccleuch), 84
Rio dei Mendicanti (Bergamo, Accademia Carrara), 99
The Outward Voyage of the Bucintoro to San Nicolò del Lido (Milan, private coll.), 94
The Coronation of the Doge (Paris, Louvre), 90
Gondola on the Lagoon (Milan, Poldi Pezzoli), 100
Pius VI giving his Blessing in Campo Santi Giovanni e Paolo (Oxford, Ashmolean) 97
The Lagoon (Paris, Bentineck Collection), 81
The Lagoon: from the Fondamenta Nuove (Edinburgh, formerly Buccleuch), 83
The Piazzetta: looking toward San Giorgio Maggiore (Treviso, Museo Civico), 80
Piazza S. Marco (Bergamo, Accademia Carrara), 89
Piazza S. Marco (Lisbon, Gulbenkian Foundation), 96, 98
Nighttime Procession (Oxford, Ashmolean), 79

Michele Marieschi
The Gran Canal at San Geremia (London, private coll.), 72, 73
The Gran Canal with the Fish Market (London, private coll.), 74-76
The Rialto Bridge with the Riva del Ferro (St. Petersburg, Ermitage), 69, 70
View of the Rio di Cannaregio (Bowhill, Selkirk, Buccleuch Collection), 71
View of the Basilica of La Salute (Paris, Louvre), 67, 68

Other Authors
Gentile Bellini: The Procession in Piazza S. Marco, 1, 2
Bernardo Canal: The Grand Canal with the Church of La Carità, 22
Bernardo Canal: The Grand Canal with the Fabbriche Nuove di Rialto, 23
Vittore Carpaccio: The Miracle of the Relic of the Holy Cross, 3
Bonifacio de' Pitati: The Eternal and Piazza S. Marco, 4
Sebastiano del Piombo: Death of Adonis, 6
Joseph Heintz the Younger: The Bull Hunt in Campo San Polo, 7
Johann Richter: View of the Giudecca Canal, 19, 20
Antonio Stom: View of Piazza San Marco from the Procuratie Vecchie, 21
Gaspar van Wittel: The Island of San Michele: looking toward Murano, 12, 13
Gaspar van Wittel: The Piazzetta, 12, 13
Titian: Ancona Madonna, 5

Essential Bibliography

P.A. ORLANDI and P. GUARIENTI, *Abecedario Pittorico...*, Venice 1753.

L. LANZI, *Storia Pittorica dell'Italia*, Bassano 1795-6.

G. MOSCHINI, *Della letteratura veneziana...*, Venice 1806.

P.J. MARIETTE, *Abécédaire...*, Paris 1851-60.

G. SIMONSON, *Francesco Guardi*, London 1904.

T. PIGNATTI, *Il quaderno dei disegni di Canaletto alle Gallerie di Venezia*, Venice 1958.

M. LEVELY, *Paintings in XVIII century Venice*, London 1959.

R. PALLUCCHINI, *La pittura veneziana del Settecento*, Venice-Rome 1960.

W.G. CONSTABLE, *Canaletto*, Oxford 1962.

P. ZAMPETTI, *Catalogue of the Guardi Exhibition*, Venice 1965.

G. BRIGANTI, *Gaspar van Wittel e l'origine della veduta settecentesca*, Rome 1966.

A. MORASSI, *Michele Marieschi*, Bergamo 1966.

A. RIZZI, *Luca Carlevarijs*, Venice 1967.

P. ZAMPETTI, *I vedutisti veneziani del Settecento*, Venice 1967.

M. PRECERUTTI GARBERI, "Michele Marieschi e i capricci del Castello Sforzesco di Milano," in *Pantheon*, 1968, pp. 37-48.

L. PUPPI, *L'opera completa del Canaletto*, Milan 1968.

T. PIGNATTI, *Francesco Guardi*, Brescia 1971.

F. VIVIAN, *Il console Smith mercante e collezionista*, Vicenza 1971.

S. KOZAKIEWICZ, *Bernardo Bellotto*, Milan 1972.

R. PALLUCCHINI, "Francesco Albotto erede di Michele Marieschi," in *Arte Veneta*, 1972, pp. 222-3.

A. MORASSI, *Guardi. Dipinti*, Venice 1973.

E. CAMESASCA, *L'opera completa del Bellotto*, Milan 1974.

W.G. CONSTABLE and J.G. LINKS, *Canaletto*, Oxford 1976.

L. DE ZUCCO, "Per Antonio Stom Pittore veneto del Settecento," in *Arte in Friuli, Arte in Trieste*, 1976, pp. 47-64.

A. DORIGATO, *L'altra Venezia di Giacomo Guardi*, Venice 1977.

J.G. LINKS, *Canaletto and his Patrons*, New York 1977.

I giochi veneziani del Settecento nei dipinti di Gabriel Bella, Venice 1978.

T. PIGNATTI, *Canaletto*, Milan 1979.

Canaletto Paintings and Drawings, London 1980.

Canaletto: disegni, dipinti, incisioni, edited by A. Bettagno, Venice 1982.

E. MARTINI, *La pittura del Settecento veneto*, Udine 1982.

A. CORBOZ, *Canaletto. Una Venezia immaginaria*, Milan 1985.

F. HASKELL, *Mecenati e pittori*, Florence 1985.

Canaletto & Visentini. Venezia & Londra, edited by D. Succi, Venice 1986.

M. MAGNIFICO and M. UTILI, *Vedute italiane del Settecento in collezioni private italiane*, Venice-Milan 1987.

R. TOLEDANO, *Michele Marieschi. L'opera completa*, Milan 1988.

W.G. CONSTABLE and J.G. LINKS, *Canaletto*, Oxford 1988.

K. BAETJER and J.G. LINKS, *Canaletto*, New York 1989.

Marieschi tra Canaletto e Guardi, edited by D. Succi, Turin 1989.

F. VIVIAN, *The Consul Smith Collection*, Munich 1989.

B. AIKEMA and B. BAKKER, *Painters of Venice. The Story of the Venetian "Veduta,"* Amsterdam 1990.

Bernardo Bellotto, Verona e le città europee, edited by S. Marinelli, Milan 1990.

A. BINION, *La galleria scomparsa del maresciallo von der Schulenberg*, Milan 1990.

M. MANZELLI, *Michele Marieschi e il suo alter-ego Francesco Albotto*, Venice 1991.

D. SUCCI, *Francesco Guardi*, Milan 1993.

Luca Carlevarijs e la veduta veneziana del Settecento, edited by I. Reale and D. Succi, Milan 1994.

Mythos Venedig, edited by G. Borghero, Baden 1994.

The Glory of Venice, edited by J. Martineau and A. Robinson, London 1994.